Painting Class:
Watercolor

Library of Congress Cataloging-in-Publication Data Available

TEXT: David Sanmiguel
DRAWINGS AND EXERCISES: Teresa Galcerán; Mercedes Gaspar; Sara Lains;
Maria José Roca; Vicenç Ballestar; Óscar Sanchís; David Sanmiguel.
PHOTOGRAPHIES: Nos & Soto

2 4 6 8 10 9 7 5 3 1

Published by Sterling Publishing Co., Inc.
387 Park Avenue South, New York, NY 10016
© 2006 by Parramon Ediciones, SA – World Rights – A division of Groups Editorial Norma
Originally published in Spain by Parramon, Ediciones, SA.
Distributed in Canada by Sterling Publishing
c/o Canadian Manda Group, 165 Dufferin Street
Toronto, Ontario, Canada M6K 3H6
Distributed in the United Kingdom by GMC Distribution Services
Castle Place, 166 High Street, Lewes, East Sussex, England BN7 1XU
Distributed in Australia by Capricorn Link (Australia) Pty. Ltd.
P.O. Box 704, Windsor, NSW 2756, Australia

Printed in China
All rights reserved

Sterling ISBN-13: 978-1-4027-4091-6
 ISBN-10: 1-4027-4091-3

For information about custom editions, special sales, premium and
corporate purchases, please contact Sterling Special Sales
Department at 800-805-5489 or specialsales@sterlingpub.com.

Translated by Michael Brunelle and Beatriz Cortabarria

Painting Class:
Watercolor

Sterling Publishing Co., Inc.
New York

Contents

The Magic of Watercolor, from within

Watercolorists are a separate community, with definite characteristics, in the world of painting. They love all painting, but they are most passionate about the peculiarities of their specialty, which makes it a unique activity within the world of fine arts. There are many aspects, but they can be summed up in one basic description: a successful watercolor always seems to be the product of pure inspiration rather than hard work. Most watercolors are completed in a single session, with no second thoughts, corrections, or repainting. The process requires a light touch, audacity, and total conviction; each brushstroke is definitive and will be visible when the work is finished. The resulting painting is a bit magical.

But the magic can be learned, and this book presents an apprenticeship based on, first, a complete familiarity with watercolor materials (few but indispensable), followed by practical application, where we study how these materials react to the actions of the painter, to his or her particular dynamics. Finally, we offer extensive step-by-step practice that illustrates well all watercolor themes using a wide range of styles and interpretations.

This book was written by watercolorists for watercolorists, whatever their level of experience, from the beginner to the seasoned painter. It was written with reverence for the process, for the thousand and one bits of wisdom within, and with admiration for those who paint. Its aim is to open up new forms of expression in a field whose possibilities seem limitless.

All good watercolors are based on an intimate combination of technique and spontaneity. Technique by itself is lifeless, and spontaneity, without any support, is chaotic. Painting by Teresa Galcerán.

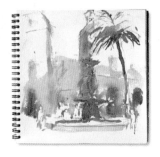

The Water-colorist's Materials

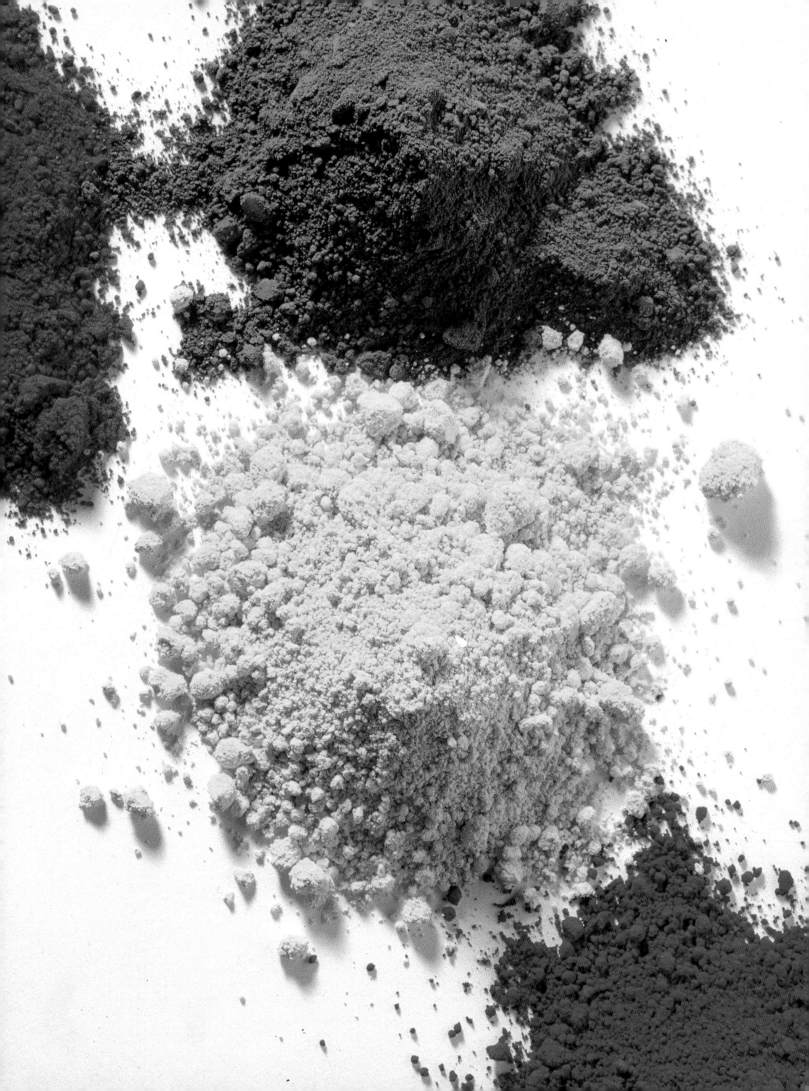

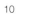

Pigments
Paints

TERESA GALCERÁN. *PINTOR EN EL PUERTO, 2004.*
WATERCOLOR ON PAPER

and Colors
Paint

and water are the basic materials **of the art of watercolor.** And there is no doubt that the splendor and sensuality of the watercolor brushstrokes have a special magnetism. But it would be a mistake to become enchanted by this spell without taking more rational factors into account. Colors must not be chosen only for their intensity or beauty, but also for their chromatic quality and their fullness when mixed with other colors. This means that besides being objects of aesthetic interest, watercolors are practical media with a function to fulfill. In this chapter we will explain what their characteristics should be.

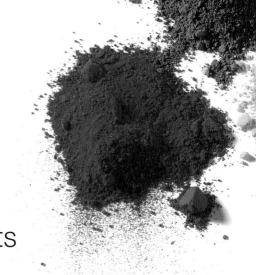

Pigments, Colors, and paints

these three words identify the three things that must not be confused. Pigments are substances with a particular chemical composition that are used in making paints of all kinds, industrial and artistic. Some of these pigments are also used to create watercolor paint. Paint can be made using a single pigment or several. Pigments have names like *chrome cobalt oxide* (used to manufacture some blue paints), *beta quinacridone* (for scarlet red paints), and *copper phthalocyanine chlorinate* (for some green paints), among many others. Colors, in reality, are notions, experiences, ideas, sensations, memories to which we give different names: when we say "sky blue" we mention an experience, a sensation, a general idea, and also a memory that will find some kind of equivalent on our palette. And finally, paint is a compound that we use for painting and evoking the experience of color.

WATERCOLOR PAINT

It is important to be clear on these distinctions, as silly as it may seem, to avoid confusion when choosing a specific paint. The name of the paint that appears on the container does not always coincide with the name of the pigment. It is also common that the name is followed by the word *hue* in parentheses; this means that the paint is an imitation of the color of the pigment, like one paint that imitates another based on cadmium or cobalt pigments. It is always best to choose good quality paint that does not contain these additives.

The color charts put out by large watercolor manufacturers are made by hand and each paint sample is real, which means that it is actually painted on the card. This fact makes it easy to check the true tone of each paint.

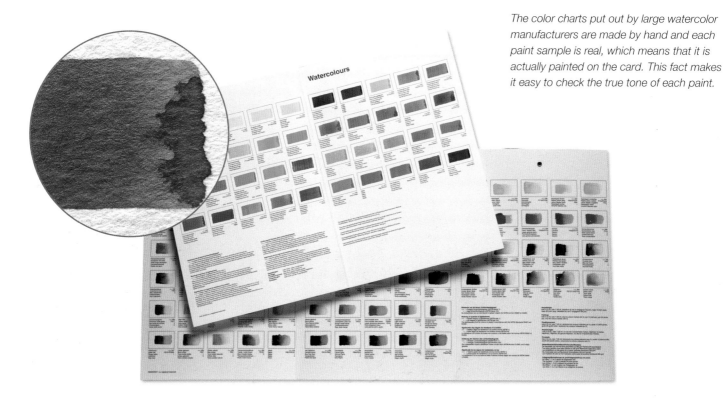

Watercolours

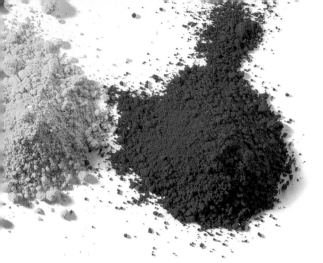

Pigments are powders of organic or mineral origin that become paint after being mixed in an appropriate media binder (oil for oil painting, gum arabic for watercolor).

THE PIGMENT CODE

The label of a tube or cake of watercolor indicates, among other information, a color denomination (lemon yellow, scarlet red, manganese blue, etc.), and a code that tells what pigment was used in its manufacture. This code has two letters and one number; the letters can be Pw (white pigment), Pr (red pigment), Py (yellow pigment), Po (orange pigment), Pg (green pigment), Pb (blue pigment), Pv (violet pigment), PBr (brown pigment), or PBk (black pigment). The numbers that follow indicate the particular variety of each pigment.

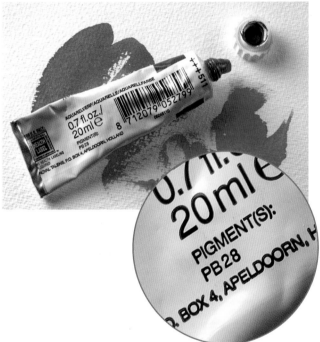

The reference to the pigment used in its manufacture is found at the bottom of a tube of watercolor paint, along with other information. In this case, it is PB 28: cobalt blue. This is the only trustworthy reference that we have for knowing the true nature of the paint.

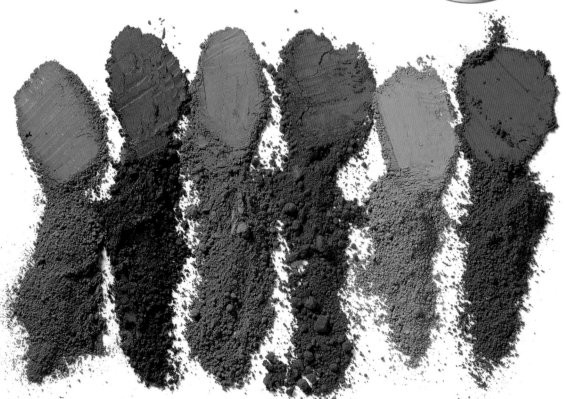

These six pigments are natural earth tones that are very rich in iron oxide, which gives them their reddish or yellowish color. Each one of them can be used to make one or several paints, depending on whether they are composed of one or several combined pigments.

Composition and quality
of watercolor paint

Quinacridone red is very transparent, which translates into great luminosity. Here it is mixed with azo yellow (also very transparent), and the resulting color is very homogenous and glossy.

Earth tones and paintings based on iron oxide usually leave sediment in the stroke because of the large size of the pigment particles. Here the granulation can be seen in a mixture of burnt sienna and raw umber.

A distinctive characteristic of ultramarine blue is the flocculation of its pigment particles, which creates a sort of fine sand in the bottom of the area of paint. This blue pigment tends to form lumps because of the intrinsic nature of its chemistry. No matter how fine the particles, they will always clump together after the paint has been applied.

Watercolor paint is made from organic or inorganic pigments bound with water and gum arabic, as well as glycerin, honey, and a preservative. When it dries, the glycerin and honey keep the paint from cracking if it is somewhat dense. The quality of a watercolor paint directly depends on the quality of the pigment and also how it was ground and bound with the agglutinant (gum arabic) and the rest of the substances. This quality is seen mainly in two characteristics: the stability or permanence on the paper without deteriorating or flaking and the solidity or resistance to fading in light.

TRANSPARENCY
The binder or agglutinant in watercolors (gum arabic) is transparent; this is why the colors are so luminous. But not all paints enjoy the same amount of transparency. The quinacridone pigments (oranges, reds, and mauves) and the phthalocyanines (greens and blues) are extraordinarily transparent and luminous, while the cadmiums (yellows and reds), those based on chromium (greens and yellows), and the iron oxides (reds and ochres) have different amounts of opacity. These differences are intrinsic to the pigments, and the artist should know them well and use them to his best advantage.

STAINING POWER

Some paints stain the paper more deeply and resist washing so much that they will not completely disappear. Excessive staining can reveal the presence of aniline dyes, which are short-lived and best avoided. Ideally you should be able to lighten the color on the paper until it almost disappears, although this works better with some colors than others, which does not reflect well on their quality.

OTHER ATTRIBUTES

Depending on the paint, the brushstrokes of color may show granules because of the larger size of the particles of pigment. This usually happens with iron oxide pigments and some cadmium colors. In other cases, like that of ultramarine blue, there is a *flocculation* effect; that is, the particles of pigment are attracted to each other and the dry brushstroke shows characteristic speckles.

Red iron oxide pigment makes very opaque paintings that sometimes can look like gouache. The same is true for chromium green and some cadmium pigments.

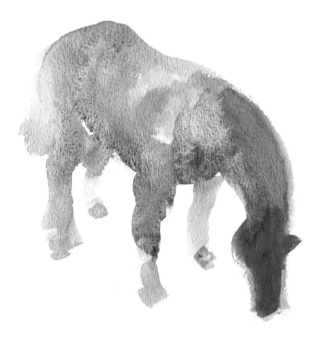

Colors like ultramarine blue do not stain the paper and can be made to disappear completely by washing them with much clean water. In this case, this is a sign of the good quality of the pigment.

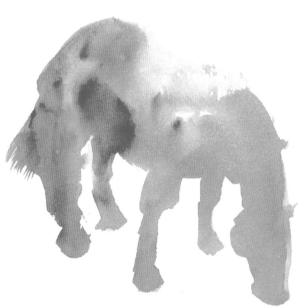

The quinacridone reds have greater staining power and the color resists removal from the paper even under intense washing. This is characteristic of the quinacridone pigments, which have an extremely fine grain.

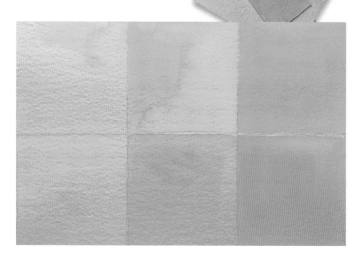

these are the most luminous, warm, and vibrant colors of the watercolorist's palette. Yellow paints are made from approximately a dozen different pigments, which can be used to make a wide range of different colors with the most varied denominations by mixing different combinations of the pigments. The six paints we have chosen here can be reduced to two or one for addition to the palette: any of them possess all the characteristics of a quality color. If you choose to use only one of them, we recommend, for practical reasons, a hansa or azo yellow.

Yellows, oranges, and reds

ORANGE PAINTS

Although orange is an easy color to make with simple mixing, it is a good idea to include an orange paint on your palette as a direct way of achieving a color with the greatest degree of warmth and saturation. The most commonly used orange is cadmium orange (PO 20), solid and opaque like all cadmium colors and also somewhat earthy and dominant in mixtures. Another more delicate alternative is DPP (di-keto-pyrrolo-pyrrol) orange (PO 73), with a reddish tendency, which is usually mixed with azo-type yellows and sold under the name of transparent orange.

From left to right and top to bottom: hansa lemon yellow, azo yellow, cadmium yellow medium, cadmium yellow light, indian yellow, and cadmium yellow dark. The hansa and azo yellows are usually very transparent and bright, ideal for the more greenish tone (lemon yellow). The cadmiums are solid and somewhat opaque and have a greater tendency toward orange. Indian yellow is very beautiful, though little used because of its weakness when mixed with other colors.

The first two pieces of fruit were painted with hansa and azo yellow respectively, and are very bright and transparent. The rest were done with cadmiums, which are more solid colors that tend to leave a very fine sediment.

RED PAINTS

There is no substitute for the chromatic strength of the reds on any palette. The wide range of reds extends from orange to violet, and it is a good idea to make use of two or three of them. As in the case of the yellows and oranges, cadmium red is the most widely used. However, one of the most typical characteristics of the cadmiums can be a drawback: the difference in the color after it has dried. Freshly applied cadmium red is quite bright and saturated, but after it has dried the color becomes muted and loses its luminosity. The napthol reds are good substitutes or complements for cadmium reds, as are the vivid quinacridone reds.

From left to right and top to bottom: vermilion, quinacridone pink, quinacridone carmine, cadmium orange, cadmium red, and quinacridone magenta. The red paints based on quinacridone pigments are transparent and luminous and have a very attractive and strong coloration. Vermilion is a traditional name for designating a color that today is manufactured with pyrrol-type pigments.

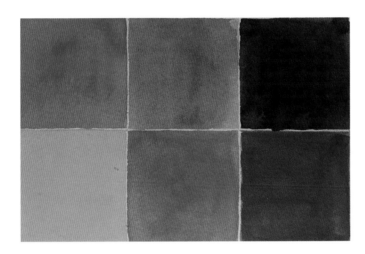

Because reds and yellows blend perfectly together, they are usually (typically) mixed to create a color, and rarely used separately.

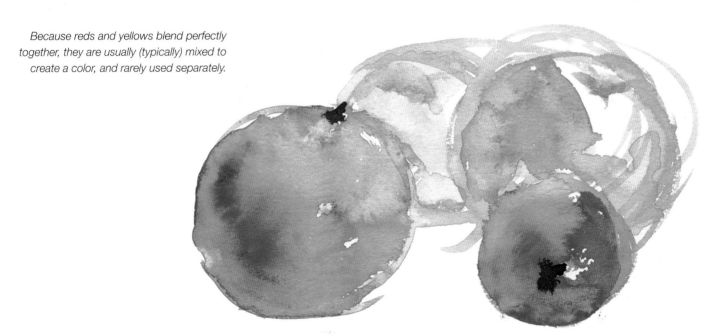

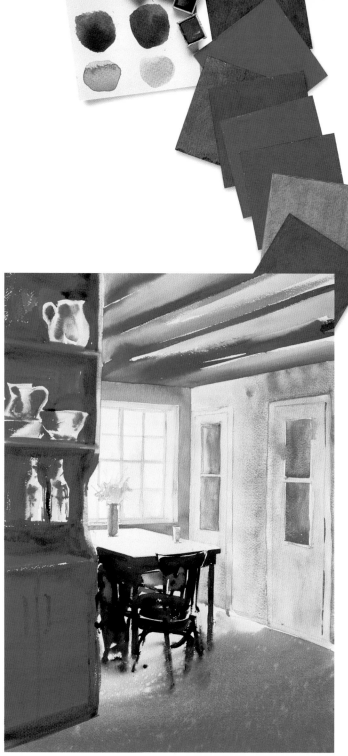

Violets, blues, and greens

Just like orange, violet can be made with very simple mixtures; however, they will never be the same as some of the spectacular purple violets that are available. Quinacridone violet is reddish, deep, and transparent like all paints that are based on similar pigments. Dioxazine purple has a strong blue tendency and looks dark and velvety. Between these two are the delicate cobalt and manganese violets; the latter are uncommon but very beautiful.

BLUE PAINTS

Ultramarine is the blue most widely used by artists, slightly violet and of deep, rich color. It is an extraordinarily useful paint, even though it leaves a visible sediment because of the flocculation of the pigment. Lighter than ultramarine is cobalt blue, which leaves delightfully beautiful washes with fine sediment if manufactured with the authentic pigment; and the very transparent and delicate cerulean blue. Prussian blue is also very common and traditional and has a lot of personality. To these must be added the more modern, extremely luminous and transparent phthalo blues.

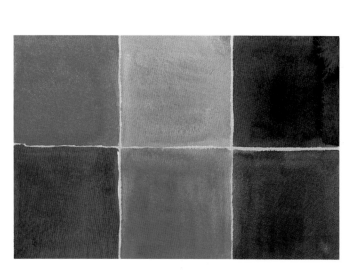

All of the blues illustrated in the range shown here appear in this watercolor. The darkest is Prussian (the chairs and the table), which could pass for black. The most luminous is the phthalo blue seen on the ceiling. The most transparent, and also very luminous, is the cerulean blue used on the right side wall; cobalt blue can be seen on the window frame and ultramarine on the floor and the kitchen shelves.

From left to right and top to bottom: phthalo blue, cerulean blue, permanent blue (dioxazine violet), ultramarine blue, cobalt blue, and Prussian blue. This selection contains the most typical blues used by watercolorists; each one has a distinct personality.

GREEN PAINTS

There are few green pigments used to manufacture watercolors, barely ten, but combining them with yellow and blue pigments renders a wide catalogue of different colors. These days the watercolorist can limit himself to the phthalo greens (with clean, bright, and vibrant tones) without needing any other green paint. However, it is worthwhile trying traditional greens like Hooker (a mixture of different pigments that make a very natural and delightful green), cobalt green, and chrome oxide green (highly opaque and slightly velvety).

Since they are generally quite dark colors, the blues can be used to develop a full range of shades just by mixing them with water.

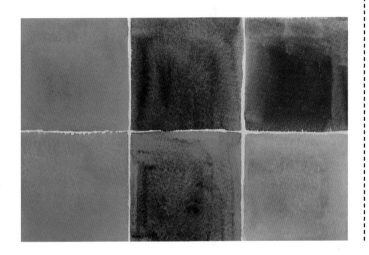

From top to bottom and left to right: phthalo yellow green, Hooker's green, chrome oxide green, permanent green, emerald green, and light cobalt green. Permanent green and emerald are varieties of phthalo; the name of the former is based on its "standard" green color, and that of the latter on its characteristic blue tendency (which is nearly impossible to capture in a photograph or four-color printing process).

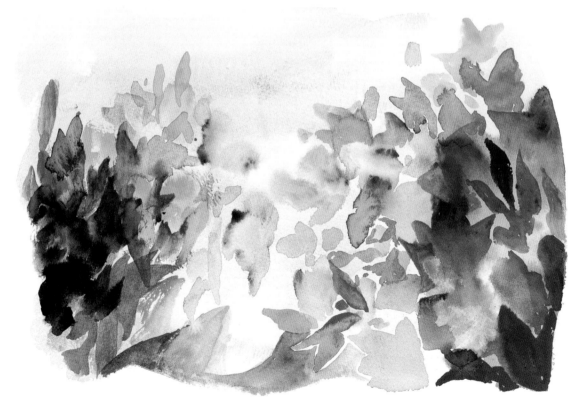

All of the illustrated greens play a part in this watercolor. What stands out most are their different levels of opacity; the light phthalo green is the most transparent, and the chrome green the most opaque.

Earth tones
and grays

Earth pigments are the easiest to obtain and are also the oldest. Traditionally, they were made from natural explosive powders (most came from Italian mines) rich in iron oxide, the reason why most of them are reddish, orange, and yellow. Nowadays they are manufactured by large chemical companies. These paints are solid and very stable and should never be absent from the painter's palette. Raw sienna is a yellow-brown pigment, which takes on a clean and transparent chestnut color when burned: the irreplaceable burnt sienna. Another common pigment is raw umber, with a green tint that can also be burned to obtain a more reddish and transparent paint. Ochre colors range between orange and bright yellow, while red earth tones like English red have a dark color, almost maroon, giving way to very opaque colors. Many of these paints are marketed under names such as Mars yellow, Mars red, and Mars violet.

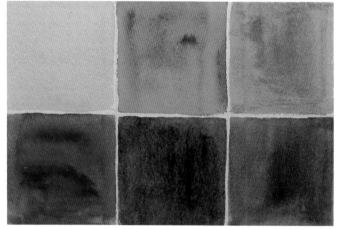

From top to bottom and from left to right: transparent golden ochre, burnt sienna, raw sienna, iron red oxide (also called English red), raw umber, and burnt umber. With the exception of the iron red oxide, all these paints are transparent.

Themes involving interiors call for warm monochromatic schemes. In this case, burnt sienna has been used.

Indigo is a very attractive gray blue that makes the definition of the shadows and middle grounds possible through transparent applications. Payne's gray is quite dark, but when diluted in water creates delicate and transparent gray glazes. Sepia tends to be used for monochromatic sketches.

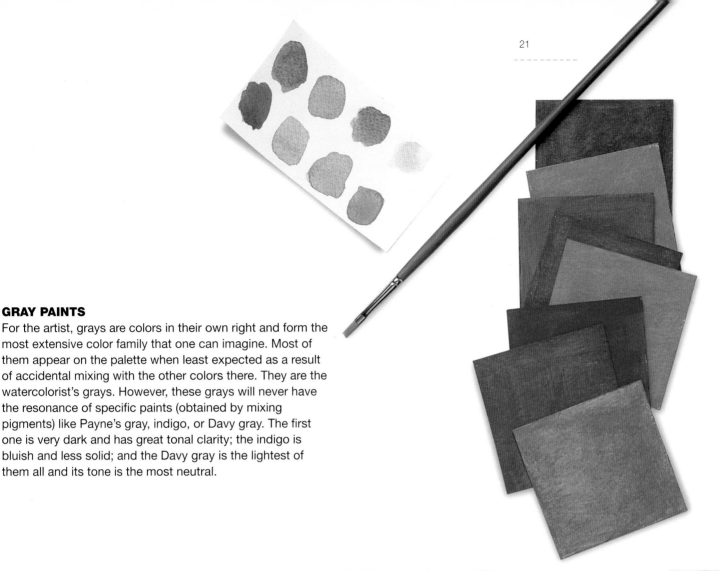

GRAY PAINTS

For the artist, grays are colors in their own right and form the most extensive color family that one can imagine. Most of them appear on the palette when least expected as a result of accidental mixing with the other colors there. They are the watercolorist's grays. However, these grays will never have the resonance of specific paints (obtained by mixing pigments) like Payne's gray, indigo, or Davy gray. The first one is very dark and has great tonal clarity; the indigo is bluish and less solid; and the Davy gray is the lightest of them all and its tone is the most neutral.

Paints created with earth pigments appear to lack brightness and vitality at first sight. This superb watercolor, created almost exclusively with earth tones, is an excellent example proving this wrong. Work by Óscar Sanchís.

Forms of paint

Some of the companies that manufacture quality watercolors are Winsor & Newton, Talens, Blocks, Old Holland, Titan, and Schmincke. Many of these brands offer the two main varieties of watercolors: liquid and paste. Paste watercolors are sold in individual tubes that the artist can dispense into the wells of the palette, and also in various assortments. Watercolor cakes (or presscakes) are available in metal boxes, which also serve as palettes. These boxes come with six, twelve, or twenty-four refillable cakes or pans, since the paints can be bought separately. Besides these generic sets, the best-known manufacturers provide many other boxes with a variable number of colors and can also incorporate any type of accessory.

TUBES OR CAKES?

Quality watercolors can be used in tube or cake form. Since every artist has his or her own preferences, explained below are some of the advantages and disadvantages of both. Tubes dispense generous amounts of paint but they can also encourage waste. Cakes supply just the amount of paint needed but it is difficult to obtain a generous amount of color, and the brush suffers from rubbing against the cakes when they are still dry. Paint in tubes is suitable for working with any type of brush, from the smallest to the largest, while the latter cannot be used with the small cakes. Cakes, on the other hand, are more compact, comfortable to use, and easy to carry.

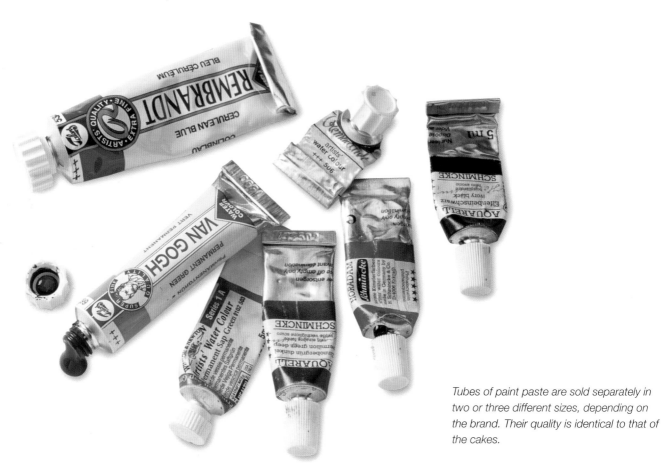

Tubes of paint paste are sold separately in two or three different sizes, depending on the brand. Their quality is identical to that of the cakes.

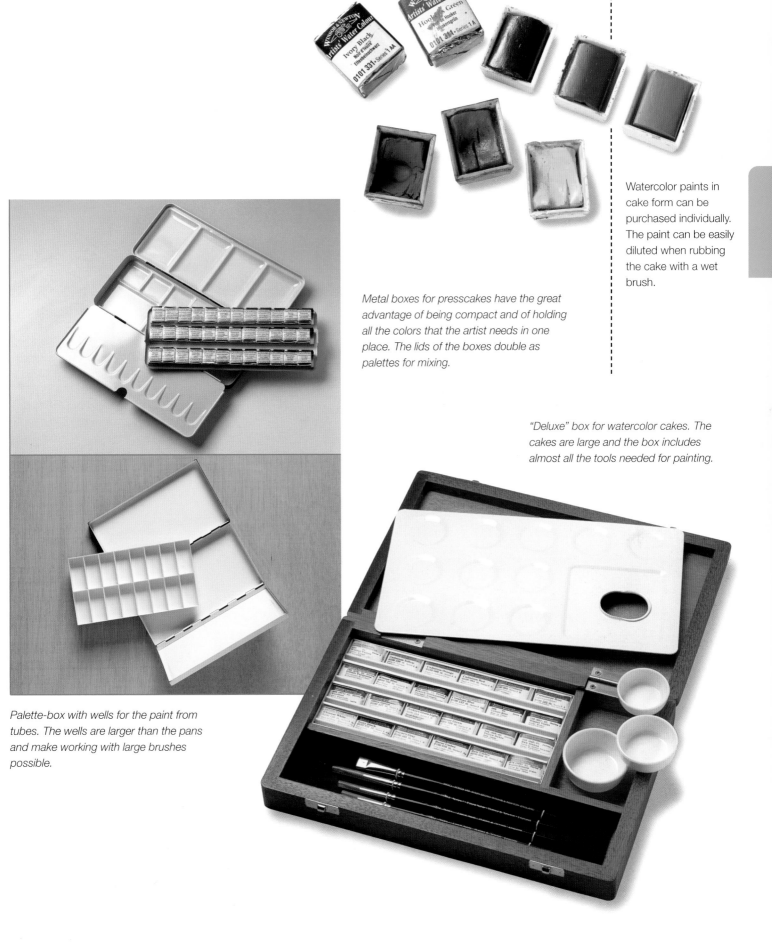

Watercolor paints in cake form can be purchased individually. The paint can be easily diluted when rubbing the cake with a wet brush.

Metal boxes for presscakes have the great advantage of being compact and of holding all the colors that the artist needs in one place. The lids of the boxes double as palettes for mixing.

"Deluxe" box for watercolor cakes. The cakes are large and the box includes almost all the tools needed for painting.

Palette-box with wells for the paint from tubes. The wells are larger than the pans and make working with large brushes possible.

palettes and Surfaces
for mixing

most of the metal boxes for painting with watercolors are also palettes for mixing them. These metal boxes are made of white enameled steel and have a series of partitions or concave wells that can be used for mixing the different colors separately. In some of these boxes, the tray that contains the paints can be removed, creating one or two palettes for mixing. Most of these palettes have a hole or a ring on the underside for the artist to hold the palette with his thumb.

Despite their unquestionable functionality and comfort for mixing colors, professional artists usually work with a single palette, whether for liquid or paste paints.

The small porcelain wells or pans are very useful when there is need for keeping strict control of each color for painting large surfaces with an even and saturated color, for example, and for preventing accidental contamination between them.

Unusual palette made by the artist with several pieces of acrylic. It is very light and easy to carry and provides a large surface for mixing.

OTHER SURFACES

White porcelain, ceramic plates, or pans of the same material can be used whenever a conventional palette is not available, or in addition to it. Some artists use dishes, trays, or plastic containers of every form and shape, even plastic egg trays. What is important is for the mixing surface to be glossy and waterproof, and that the resulting color can be clearly discerned.

SCRAP PAPER

Many professionals use a piece of watercolor scrap paper where they can test the mixtures before they are applied to the painting. This is a good idea because often the color mixtures are difficult to identify until they have been tried on the paper.

The watercolor artist places a piece of scrap paper beside the work to constantly test the color of the mixtures and the amount of water in the brush. This paper should be the same kind as the one used for painting the work.

In the studio, many watercolor artists use ceramic plates and other utensils for mixing colors. The bright white of ceramic or porcelain makes it possible to control the exact tone of each mixture.

The Palette as a Working
tool

the palette is half of the watercolorist's equipment. The other half is the brushes and the paper. Every worker must be in tune with his or her tools, especially the artist, who needs to get the best use out of the tools. The watercolor artist must feel comfortable with the palette, and the color selection must be justified by his or her approach (it is absurd to have colors that will never be used).

The size of the palette varies. On the following pages we will show a very large and heavy studio palette made of steel, useful for large work that requires many large surfaces for mixing. However, no artist would think of carrying such a large tool for working outdoors, where he or she would utilize conventional palettes or light palettes with cakes.

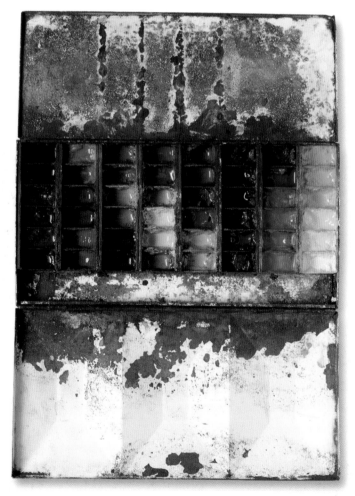

Enormous box-palette with room for forty-eight different colors. In reality, here the colors are duplicated to make sure that there are enough supplies during long studio sessions and for large-format paintings.

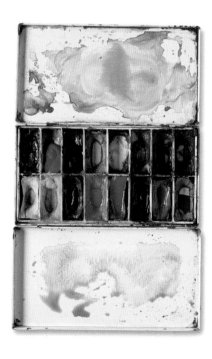

Box-palettes with wells for paste paints are used both in the studio and outdoors. They can hold quite a bit of paint and provide large surfaces for mixing.

EMERGENCY TUBES

Watercolor artists always carry several tubes of their most frequently used paints in case they are needed during their outings. These tubes can be used to dispense the paint directly into the palette's wells or pans. Sometimes, from lack of use, the paint dries out inside the tube. In such cases, the paint can still be used by simply cutting through the outer tin or plastic shell and using the contents as cakes.

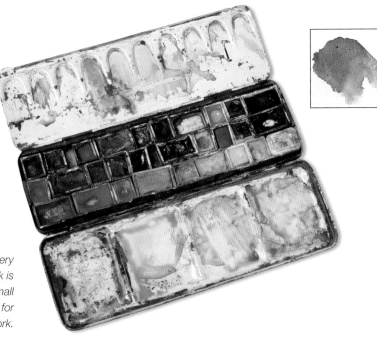

The boxes with paints in cake form are very useful for painting outdoors as long as the work is not too large. They are ideal for making small sketches and color studies, but less practical for large-format work.

Clean colors are achieved only when the mixing surface is clean as well. Otherwise, the colors always have a gray undertone.

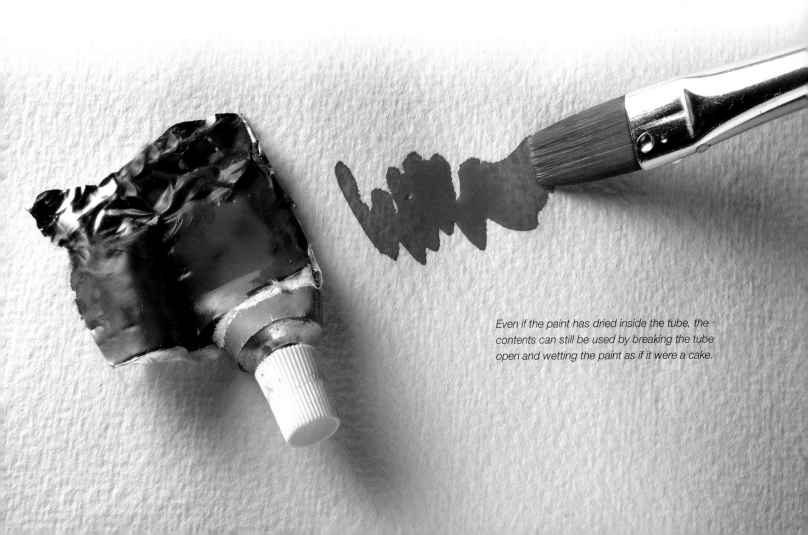

Even if the paint has dried inside the tube, the contents can still be used by breaking the tube open and wetting the paint as if it were a cake.

Watercolor paper

and the brushes.

Any true watercolor artist

loves and knows his or her papers

well. Paper is almost one more dimension of art. A good paper nobly responds to all the requirements of the artist, endures long work sessions, and later recovers its surface integrity. The colors blend on the surface of a good paper and form part of its own substance. It has an incomparable sensual quality: to the eye, the touch, and even the ear. Brushes are also important, but are not as determining a factor as the watercolor paper.

for no other medium is the quality of the paper as crucial as for watercolor painting. The paper is not only a surface over which paint is applied, but a living body that responds by adjusting to the artist's intervention. The surface texture, the sizing, the weight, and the fibers from which paper is made are factors that significantly determine the results. Water absorption changes the context of the paper and the colors look very different according to that absorption. The watercolorist must intimately know the support used, and there is no other way but trying out different papers until the one that best responds to the artist's style, work dynamic, and sensibility is found.

papers for Watercolor
Painting

This is the consistency that the pulp should have after being properly blended in a vat with large amounts of water.

COMPOSITION OF WATERCOLOR PAPER

A piece of paper is a sheet made of cellulose fibers, the main substance of vegetable fibers. This cellulose can be extracted from wood, cotton, linen, and many other plants. Quality watercolor papers are made of linen and cotton fibers, the latter being the best for their durability and greater absorbency. To ensure the performance of watercolor paper and prevent it from turning yellow with time, it must be acid free; those acids come from substances in the vegetable fibers themselves or from the chemical compounds used for breaking them down or for separating the water used in the processes of fiber maceration. Therefore, the labels *100% cotton* and *acid free* are the ones we are interested in finding in the manufacturer's literature.

Handmade sheets of paper are manufactured by dipping a mold (a large one in this case) in the vat containing the pulp. The mold is a metal screen stretched on a frame that retains only the pulp.

FABRICATION

Raw vegetable fibers are turned into paper pulp after fermentation with water and lime and a process of straining and refining whose goal is to strain the fibers without damaging them. Following the complete maceration of the pulp, it is diluted in a large amount of water to which several additives (whiteners, glues, etc.) have been added, and they are mixed in large vats. In industrial processes, the pulp is poured over several cylinders of different temperatures that subject it to different degrees of pressure, turning it into a thin continuous sheet that is later cut into smaller sheets. In the production of quality watercolor papers, special cylinders are used that dispense the paper sheet by sheet, without cuts, which causes the deckled or frayed edges.

HANDMADE PAPER

The ancient artisanal methods of making paper have been revived by small companies or paper mills that provide high quality papers in rustic finishes. These sheets of paper are produced individually and dried in the sun or in carefully ventilated rooms. They offer an appealing opportunity for the artist at an affordable price.

The mold is what actually shapes the sheet of paper, which, after being placed on a felt blanket, is left to dry until it is ready to be used by the artist.

The frayed borders of watercolor papers indicate that they have been made one by one. These frayed borders are called deckled edges.

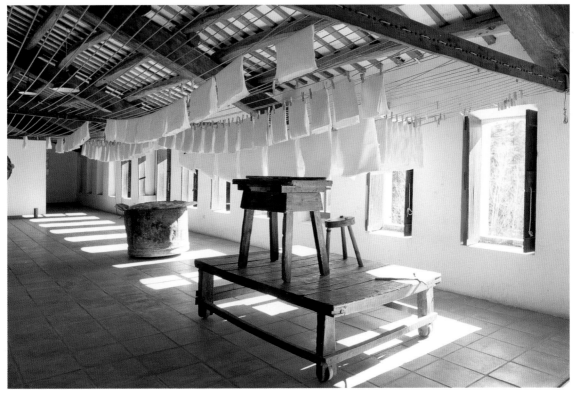

Paper drying room in a traditional mill for producing handmade paper. The sheets are dried by the air and the sun, not through induced heat and pressure.

Texture
and Finish of the paper

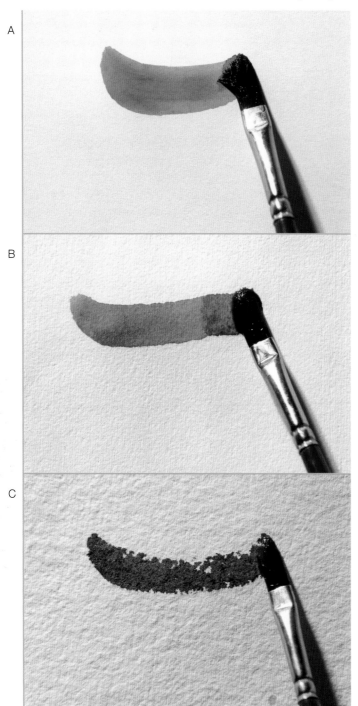

among the various professional quality papers, watercolor paper is generally produced with three textures or finishes: hot pressed, cold pressed, and rough finish. Hot pressed paper is pressed with hot rollers or presses to flatten it and tends to have a light texture that provides some tooth for the paint. The thin paper, which can be glossy in some brands (Arches), requires the artist to carefully control the edges of the brushstrokes and the color blending, and the gradations and washes, since the drying time is much faster and is not conducive to much touching up. The appearance of puddles (changes in the intensity of an area of color) is almost inevitable with this type of paper, due to the almost successive application of colors. It is not an easy paper, and it tends to be the one preferred by illustrators; it offers the advantage of maximizing the luminosity of the colors.

ROUGH AND VERY ROUGH FINISHES
Cold-pressed paper provides a texture that partially eliminates the need for quick and very controlled work. It is the most suitable paper for most watercolor artists. Rough finish papers (and handmade papers among them) have not been through the presses and offer a very rough texture that accumulates and retains water, delaying the color's drying process. This variety of paper takes away the luminosity of the colors but makes long painting sessions much easier. It is a variety that responds better to the realities of the work of the modern watercolor artist.

Satin watercolor paper is used mainly for illustration work. The colors look clean and even, and the brushstroke is very light. (A)

Cold-pressed paper is suitable for delicate work that requires precision and not large amounts of water. (B)

Rough papers make the texture highly visible after each brushstroke. This type is suggested for works that need heavy painting and that require large amounts of water. (C)

Two surfaces of watercolor paper, cold pressed and rough texture. The configuration of the texture depends on the manufacturer.

WEIGHTS

Each one of these three varieties is available in different weights, which are based on the weight of a ream of paper (500 sheets). A good, large watercolor paper should be at least 140 lb (300 gsm). A heavyweight paper can absorb more water without buckling and can withstand all kinds of touch-ups, even aggressive ones, without any visible damage to the surface. Every manufacturer provides papers of different finishes and weights, so it is important to try out different ones to find the one that best fits the personal needs and taste of the artist.

SIDES OF THE PAPER

All these papers have a front side and a back side: the side that has been in contact with the mold has a different texture than the one that is laid on the felt. Either side can be used for painting because both have identical or almost identical sizing. The only difference is the texture of the surface, which partially determines the finish of the work.

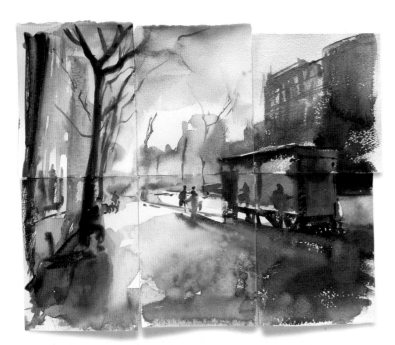

This watercolor has been painted over six different pieces of watercolor paper attached at the back. Each piece has a different texture and weight.

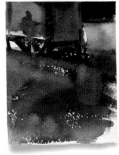

The differences can be seen when the pieces are separated. The papers have more texture as they go from left to right (the smoothest to the left); the heavier ones are on the bottom.

dynamics
of Paper

It is common knowledge that water makes paper buckle, especially as the papers become thinner. This is one of the reasons why watercolor papers must be heavy. Even then, buckling is inevitable while working wet on wet. Good quality paper recovers its shape after drying, but with light papers total smoothness is possible only if the paper is previously stretched. Water also makes the cellulose fibers swell, throwing them out of order and making them easy to separate if the sheet lacks some type of substance that provides firmness and cohesion. This substance is glue or a sort of gelatin, which allows the surface to recover its consistency and prevents the fibers from separating.

SIZING

During the production process, the watercolor paper receives a "mass" sizing, that is, one inside and the other on the surface. This allows the fibers to recover their consistency after the paint has dried. Each variety of paper calls for and each manufacturer chooses a different sizing process, and this determines the paper's behavior during the work. If we paint directly, the surface sizing reduces the paper's ability to absorb and the color dries on the surface of the paper, resulting in clearer and more delicate strokes. If we wet the paper just before beginning to paint, the paint penetrates the paper and the result is more airy and less luminous, but it gains in density as a result of the greater amount of pigment present in the stroke.

A paper without sizing acts as blotting paper: the water is absorbed immediately.

A paper with sizing prevents water from being absorbed for some time. Watercolor papers should have the right amount of sizing to absorb water at a rate that is favorable for the work.

Some watercolor artists wet the paper before they begin painting to dilute a good portion of the surface sizing and make the paint penetrate deep into the paper's fibers.

PUDDLES

When an artist works with papers that have a great amount of sizing on the surface or when the paper is very smooth, the color has difficulty penetrating the paper and the water tends to form puddles on the surface. This causes blotches and stains that are darker in color when the paint dries. Those who use these papers to make illustrations or renderings of technical drawings avoid puddles by carefully controlling the amount of water (little) used in each color application. Artistic watercolor painting accepts accidental or "crude" results, which are not censured as long as they respond to a clear and effective artistic intention.

Water buckles and deforms the paper. The weight of the paper reduces this effect, especially in small formats.

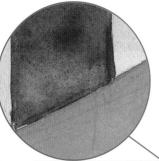

This watercolor has been painted without dampening the paper beforehand. The colors are cleaner and cooler. The texture of the painting in one work and the other can be compared in the detailed enlargements.

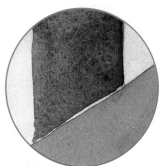

Colors become denser and spongier when working on paper that has been dampened beforehand. The enlargement shows that sponginess, which is due to the fibers of the paper being out of order.

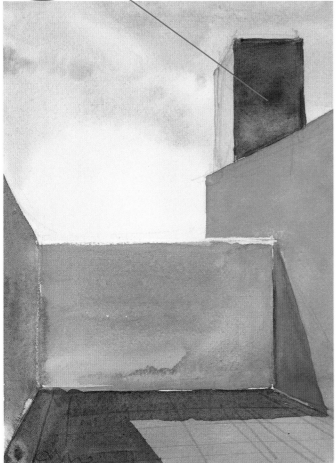

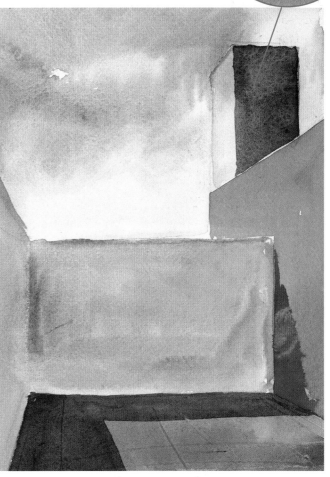

preparation and Use
of Paper

Papers that are large or light should be stretched. To do this, first they must be wetted, practically soaked in water, for example, by placing the sheet under running water or putting it inside a tray.

The wetted sheet is secured to a board with gummed paper tape along its four sides. The glued tape does not come off after it dries, so it is necessary to cut it off the sheet on all four sides with a blade once the work is finished.

A top-quality sheet of 140 lb (300 gsm) or more of watercolor paper does not need any preparation: we can begin painting on it right away. The curling that the water will inevitably produce (especially if used in large quantities) will not ruin the work and can be fixed by pressing the dry watercolor under the weight of a few heavy books. Lighter or lower-quality papers need to be stretched on boards on all sides to limit buckling and to make the recovery of the shape during the drying process easier.

STRETCHING

Less expensive papers can be stretched on boards with a simple procedure, which consists of wetting them with abundant water and securing them to the board with gummed tape. After drying, the sheet is completely stretched and ready for painting. Although curling may take place during the painting process, the paper will recover its perfect shape once the watercolor is completely dry.

This approach is highly recommended when using the papers mentioned before, which are large or very large.

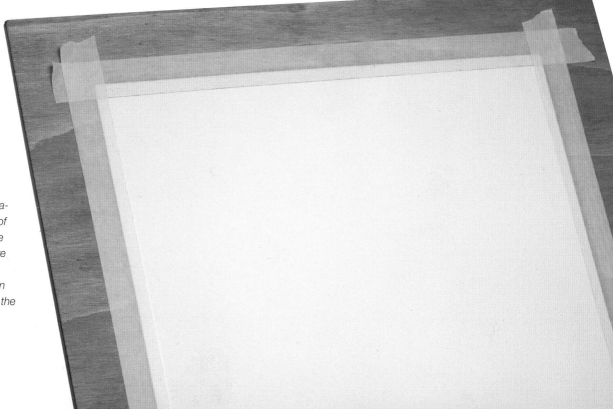

When good-quality paper is used for most of the medium and large format work, it is more than enough to use masking tape that can easily be removed at the end of the work.

PADS AND SKETCHBOOKS

High-quality paper is also sold in pads of sheets that are glued on their sides, so that the stack of sheets forms a single body. This glue fulfills the same function as the masking tape mentioned before. When the painting is completely dry, the sheet is separated from the rest with a knife or a letter opener.

Finished watercolor with the masking tape still attached on its four sides. Many times it is not necessary to tape the sides completely; it is enough to tape them so the paper will not buckle too much.

Loose sheets of watercolor paper, if they are light, must be stretched or secured to a board. The sheets available in glued pads can be painted on directly; after the work is finished, the sheet is separated from the rest with a letter opener. Sketchbooks do not need any preliminary preparation and can be used like any other notebook.

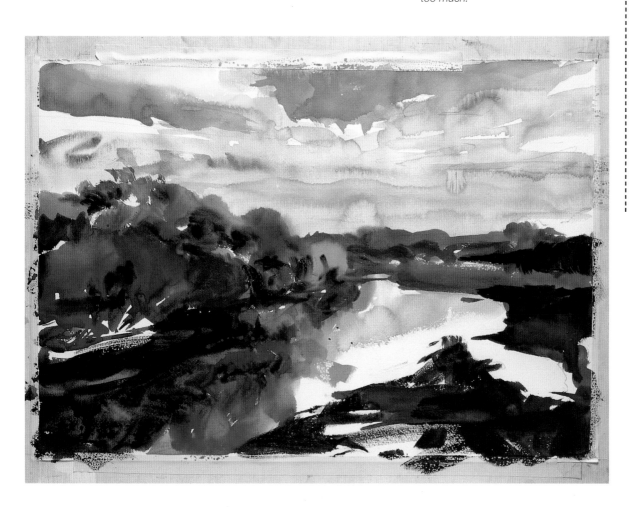

Watercolor brushes should be made of natural hair or special synthetic fibers. The different hair qualities mainly determine the brush's quality, and the size and the characteristic shape of the tip (round or flat) make it suitable for different functions. However, the quality of the brush is less important in determining the success of the work than the quality of the watercolor paper.

Brush made of very soft squirrel hair, ideal for applying large washes. It is expensive, although its shape and finish make it the most appealing of all brushes for watercolors.

brushes
for Watercolor Painting

QUALITY OF THE BRUSHES

The characteristics of a good brush can be summarized as follows: it should be soft, and have great capability for carrying diluted paint, for bending at the smallest pressure, and above all, to recover the shape of the hair and the tip immediately. All these qualities can be found in the *Kolinsky* sable hair, selected from the hair of the small animal's tail. The fabrication process of these brushes is very labor-intensive, which explains their extremely high price. They are followed in quality by the mongoose and squirrel-hair brushes and brushes made with the hair from the ox's ear. Synthetic-hair brushes have taken over because of their performance and affordability, which compensate for their short life. Nowadays, there are many varieties of natural- and synthetic-hair brushes available that satisfy the needs of most watercolor artists, especially beginners. Our advice is to buy brushes of different shapes and sizes that are not too expensive.

Synthetic-hair brushes are very affordable, their only drawback being their short life. The best one among them is the flat brush, which maintains its shape the longest.

Sable-hair brushes (shown here with the hair dry and charged with water) are of the highest quality and also the most expensive. They are not a requirement, and natural- or synthetic-hair brushes are an adequate substitute.

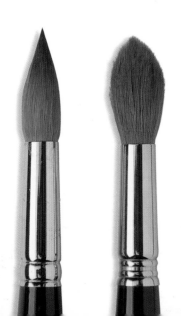

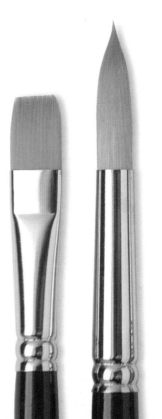

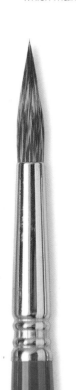

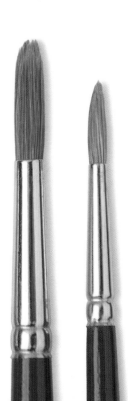

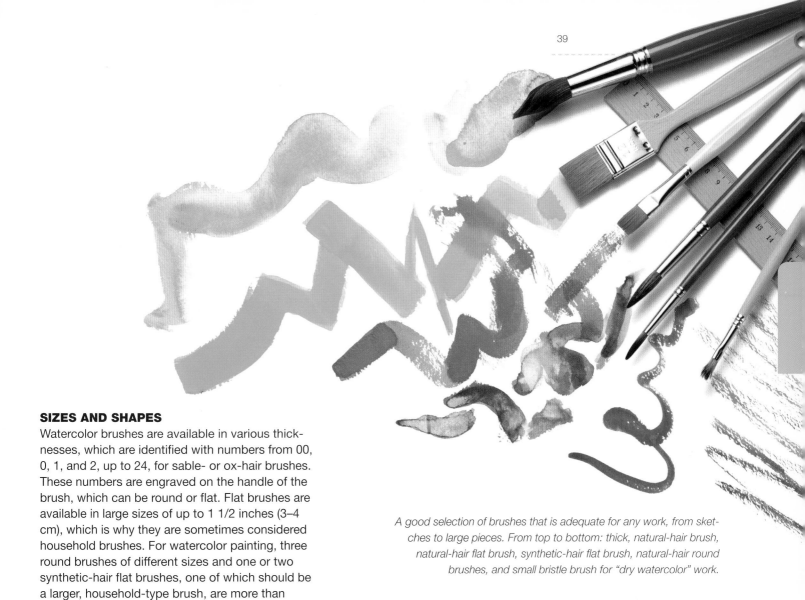

SIZES AND SHAPES

Watercolor brushes are available in various thick-nesses, which are identified with numbers from 00, 0, 1, and 2, up to 24, for sable- or ox-hair brushes. These numbers are engraved on the handle of the brush, which can be round or flat. Flat brushes are available in large sizes of up to 1 1/2 inches (3–4 cm), which is why they are sometimes considered household brushes. For watercolor painting, three round brushes of different sizes and one or two synthetic-hair flat brushes, one of which should be a larger, household-type brush, are more than enough.

A good selection of brushes that is adequate for any work, from sketches to large pieces. From top to bottom: thick, natural-hair brush, natural-hair flat brush, synthetic-hair flat brush, natural-hair round brushes, and small bristle brush for "dry watercolor" work.

Big flat brushes are necessary for large work and also for applying large and even washes. They are available in many sizes and varieties of hair.

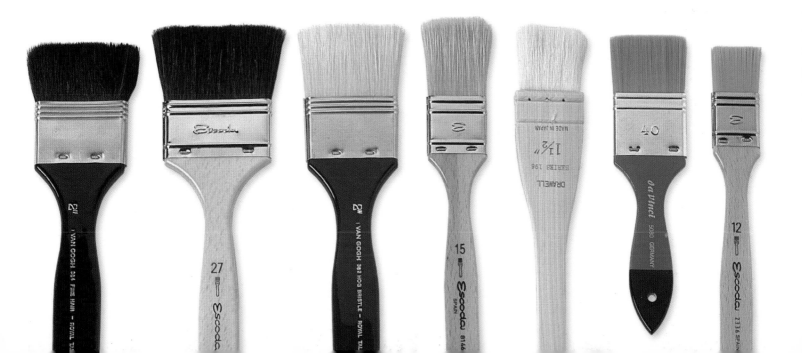

Working Methods and Habits

Although most artists use only one large jar for water, it is helpful to have a second jar just for charging the brush that has been previously cleaned in the large jar.

Painting with watercolors should be, first and foremost, a pleasurable experience. A certain level of anxiety before beginning a work (an anxiety felt by even the most seasoned professionals) is normal, but it is a mistake to make too many arrangements and take too many precautions in anticipation of possible (and probable) mistakes. The work should proceed at a relaxed and steady rhythm responding to a basic principle: if we doubt, better not paint; if we paint, better not doubt. Hesitation, although inevitable at the beginning, visibly weakens the results. An honest mistake can produce interesting results, and at any rate it is always better than a timid or poorly disguised one.

WATER AND CONTAINERS

We will need a lot of water, approximately 2 cups (½ L) in a container with a wide opening. The most common approach is to work with a single container until the water gets murky and needs to be replaced. Even though murky water has some advantages, there is the possibility of using two containers: one for cleaning the brushes before changing colors and the other for charging them with clean water.

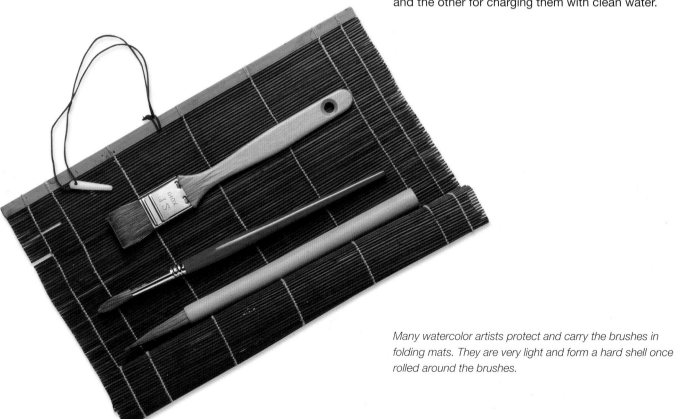

Many watercolor artists protect and carry the brushes in folding mats. They are very light and form a hard shell once rolled around the brushes.

A natural sponge is a tool that is as necessary as a brush. It makes wetting the paper easy, and can sometimes be used to spread the paint.

DRYING SURFACES

A drying surface (a rag or soft paper) for removing excess water from the brush after it has been submerged in water or used for mixing on the palette is as important as water itself. The ideal rag is an old towel, but it is also a good idea to have a roll of toilet paper to wipe off the brush to control the level of moisture.

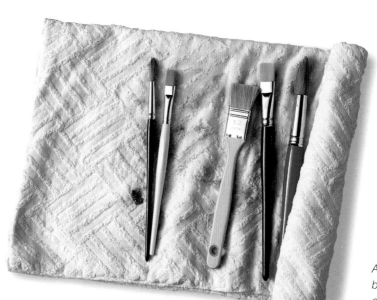

An old towel can double as blotting paper, with the added advantage that it can also be used to protect and carry the brushes.

Absorbent paper (in sheets or rolls) is useful for ridding the brush of excess paint and for drying it.

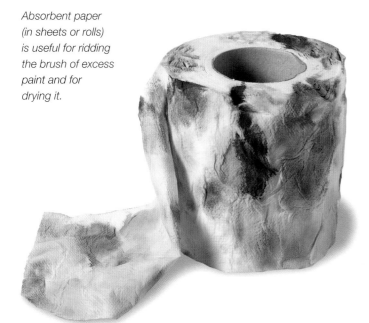

This interesting implement is useful for squeezing out the last bit of paint in the tubes. The two rollers apply pressure on the tube, and the movement of the lever squeezes out the paint.

Basic painting

Tech-niques

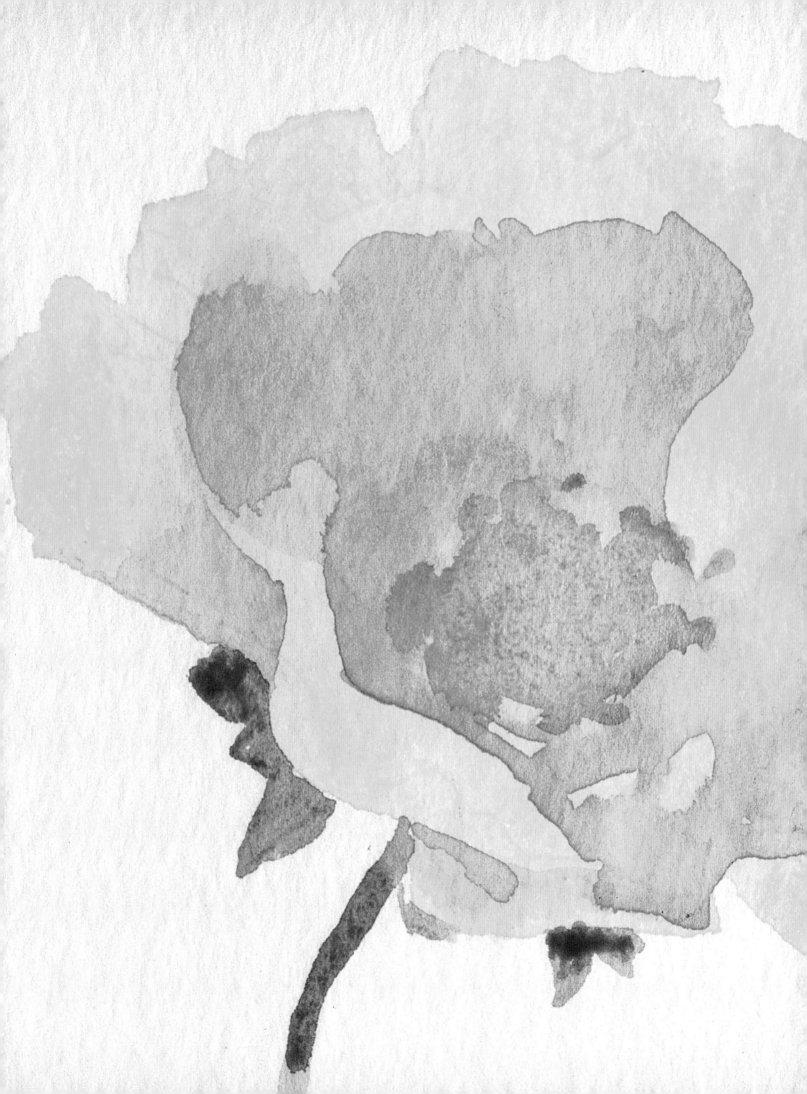

Water, Brushstrokes

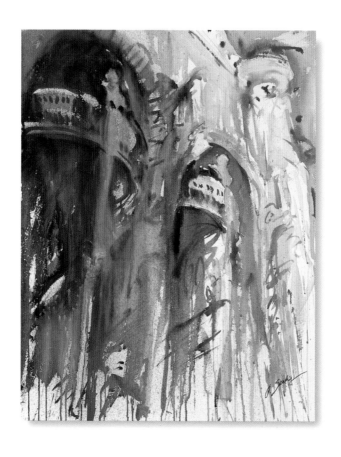

ÓSCAR SANCHÍS. LA PEDRERA, 2003.
WATERCOLOR ON PAPER

and Brush.

Water is, in fact, the protagonist of

watercolor painting. Watercolor, more than any other medium, depends entirely on the element used to dilute it. Water determines the consistency of the color, its tone, its transparency, and the mixtures with other colors. This water dependency makes watercolor an art with some unique technical characteristics, and one to a large degree independent from drawing and coloring in the widest sense of the word. The handling of water and moisture, of the effects and the strokes produces results of incomparable vitality, without which it would not be possible to speak of watercolors as a whole.

Controlling
the Brushstrokes

For traditional artists in China and Japan, painting and drawing are no different at all: the brush paints and draws simultaneously, and each stroke depicts a form and a color at the same time. Something similar is true for watercolors from a Western point of view: a brushstroke is not just another stroke among many, but a form drawn and colored. Such is the importance of the brushstroke that it is worth studying it by itself, noting how the pressure and the movement exerted by the hand and the smallest turn of the wrist can immediately affect the appearance of the stroke on the paper.

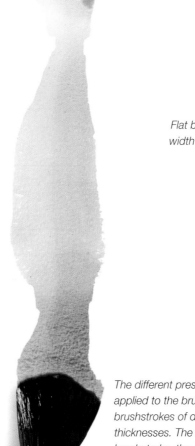

Flat brushes produce a stroke whose width is consistent as long as the hair is not twisted and is applied completely flat on the paper.

Applied sideways, a flat brush produces sharp strokes that help create straight lines and geometric shapes.

The different pressure that is applied to the brush results in brushstrokes of different thicknesses. The thicker the brushstroke, the greater the difference between brushstrokes.

THE PRESSURE AND MOVEMENT OF THE BRUSH

We can produce thick brushstrokes with large amounts of water by applying pressure on the brush. The lines will be thinner if less pressure is applied, to the point that we will be able, with practice, to draw very thin lines (if we use a quality brush with a perfectly pointed tip). Controlling the pressure allows us to draw lines of various shapes and thicknesses. The shape of the tip plays an important role: we will be able to obtain a greater variety of strokes with round brushes; flat brushes will help us create sharp effects and strokes of a perfectly even thickness.

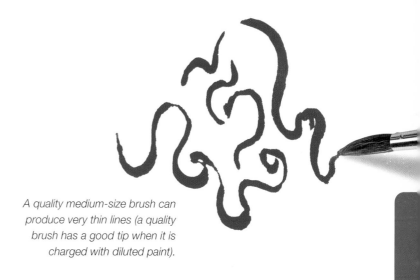

A quality medium-size brush can produce very thin lines (a quality brush has a good tip when it is charged with diluted paint).

With the same brush used for drawing the thin red lines, we can create much thicker rounded lines by simply increasing the pressure applied on the tip.

This flower has been painted with a few quick brushstrokes using only one medium-size brush.

Painting and drawing are the same thing when the brushstroke takes center stage. The differences in thickness, tone, and design provide all the charm in these sketches.

Controlling
the Amount of Water

These seven apples have been painted with the same Hooker's green in different degrees of saturation. It is a very simple and useful exercise to practice control of the charge.

Controlling the amount of water applied on the paper is as important as controlling the brushstroke. Too much water shatters the work and leaves circles when the color dries; an insufficient amount of water slows down the course of the brush and forces the artist to touch up constantly. If there is too much water, we can remove part of it with a piece of scrap paper or a rag or towel; excess water on the paper can be removed by absorbing it with blotting paper or with the clean and dry brush itself.

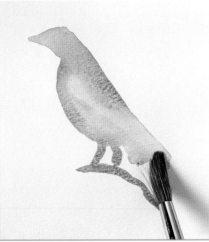

The accumulation of color left behind after lifting the brush from the paper can be eliminated by brushing it again with a dry or semi-dry brush.

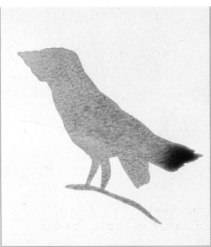

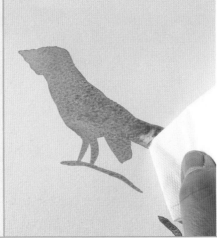

Another way of removing excess paint from a layer is by touching up the drop with a piece of blotting paper.

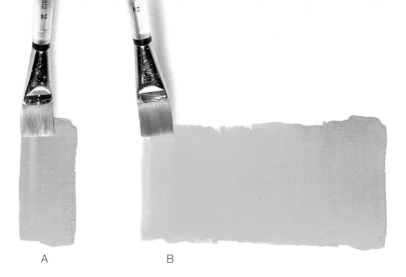
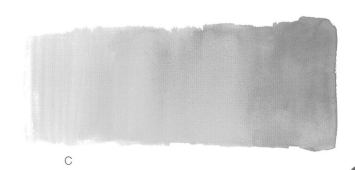

A B C

APPLYING A GRADATION

Watercolor paints are made lighter with water, and it is possible to obtain different tones (values) of the same color depending on the amount of water used. This is the premise for gradations: a mass of color with a decreasing level of saturation. Gradations are typical in the painting of landscapes (skies, water, atmosphere, etc.) A generous amount of paint is applied on the upper part of a paper that has been securely attached to a board, which in turn has been slightly tilted toward the painter. The paint is extended downward with the brush (preferably flat). When we run out of paint, we charge the brush again with only water, and the wet area of color is again spread downward until we achieve a soft, gradated surface.

The gradation is carried out with the paper slightly tilted. First, the color is applied on the upper part of the paper and extended downward with a flat brush, using parallel brushstrokes from right to left and vice versa. (A)

When we run out of paint, we charge the brush with only water and we continue with the process. The color will become lighter little by little and will concentrate on the lower part of the mass, from where we can continue spreading it. (B)

In the end, we will obtain a mass of color with decreasing saturation and without visible brushstrokes, since it has been executed without letting the color dry before finishing the operation. (C)

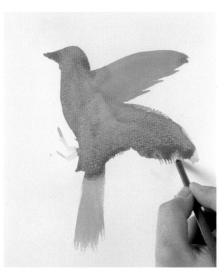

The excess liquid on a layer of color can be used to create intricate details with the tip of the brush.

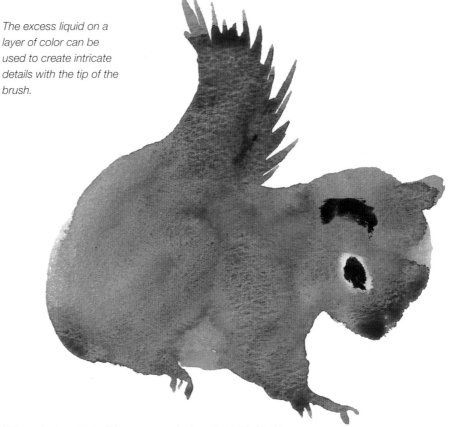

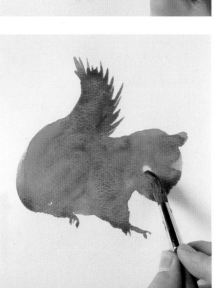

If the color is wet, it will be very easy to "create highlights," to expose the white paper in a required area by simply touching up with clean and dry brush.

analyzing brushstrokes
and Typical Watercolor Effects

much can be learned by carefully observing different watercolors, trying to figure out in detail how the artist applied the stroke, how much water and paint he or she used, which colors were used and in what proportion, how much the texture of the paper came into play, and so on. In this sense, observation and analysis of the results of one's own paintings and those of others is almost an art form in itself, because we are mentally reconstructing the process and learning from it.

"QUICK" AND "SLOW" WATERCOLORS

A watercolor painting can be resolved with half a dozen strokes or be the result of a long process. The first approach, which can be called a quick watercolor, offers many more opportunities for exercising the imagination, since its effects are much more obvious. In this type of work we can begin to identify every action, as well as the artist's expressive intention that has governed his or her work. "Slow" watercolors are more elaborate and defined; the effects are exactly the same as in the quick ones except for being less obvious.

The very diluted sienna color has been applied over the recently applied yellow layer. This is why the paint has been incorporated and almost mixed in with the base yellow.

In some areas the brushstrokes of sienna have been applied with a very dry brush: the brushstrokes emphasize the texture and do not cover the paper completely in that area.

Sienna and yellow were previously mixed on the palette before they were applied here. The resulting color is a light chestnut with an even tonality.

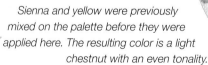

Form and color are executed simultaneously in these strokes applied with the tip of the brush (with very diluted paint), which describe right away the branch and the bird's feet.

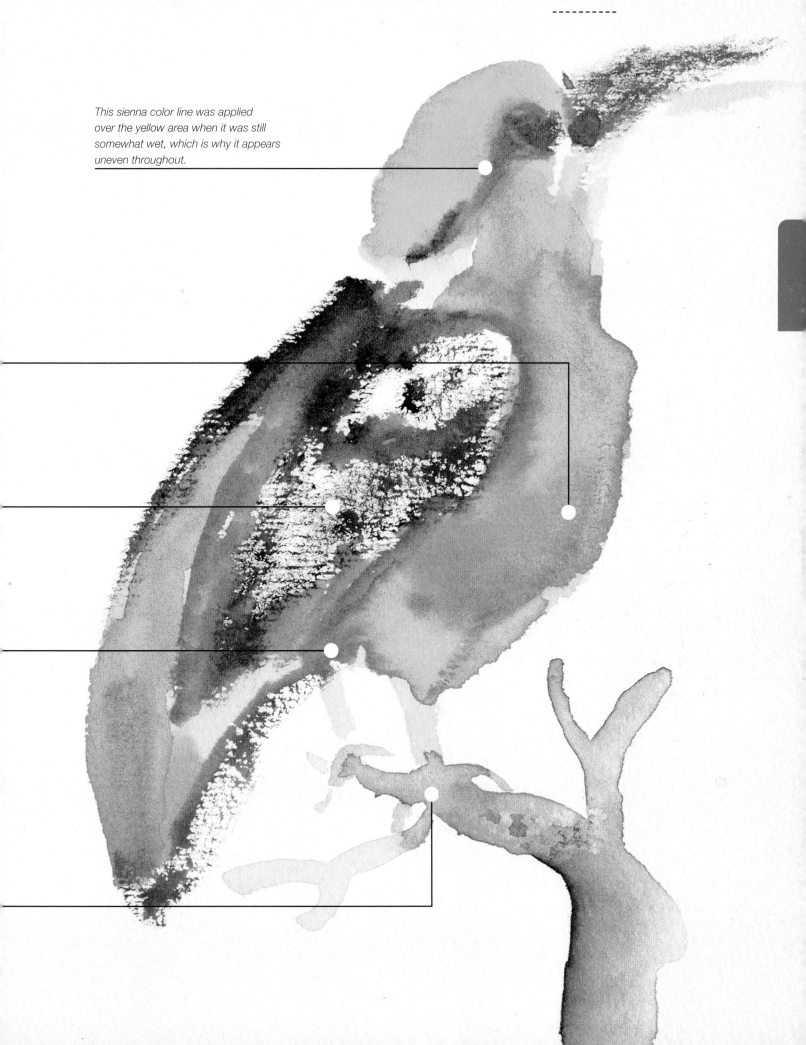

This sienna color line was applied over the yellow area when it was still somewhat wet, which is why it appears uneven throughout.

the color of the Paint
on dry paper

the first instinct when sitting in front of the paper with all the paints and the tools is to begin painting without further ado. But the first instinct is not always the best, and painting directly on dry (called wet on dry) is somewhat unusual among watercolorists. We will understand why later on; for the time being we will limit ourselves to studying what happens when we apply the color on the paper and what results we expect to see when we work this way. These exercises have been executed with a single natural-hair, medium, round brush.

1

1. The large yellow area represents all the petals of the flower. Once the color has been applied and the outlines have been adjusted with the tip of the brush (without using a drawing), we work on the smallest details of the outline, spreading the water with the tip of the brush.

2. When the first layer is completely dry, we add a second, more saturated layer of yellow. If the first layer was completely dry, the second one will behave as if it had been applied over the white paper: the edges will be perfectly defined.

2

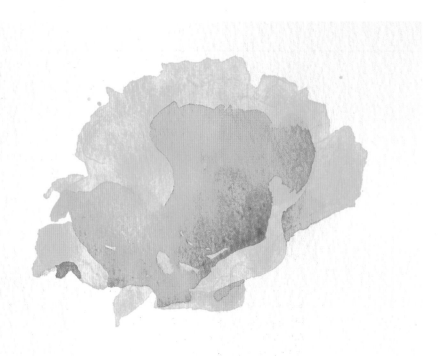

3

3. The new color will not mix with the base yellow at all because it was completely dry before we painted over it, and also because we have not worked it too much or rubbed it with the wet brush.

Painting and drawing are practically synonymous in painting watercolor on dry paper, especially when dealing with simple sketches or studies created with very few brushstrokes.

BRUSHSTROKES THAT ARE FLOWERS

Strokes of color are easy to control when working on paper that is completely dry. It is simply a matter of guiding the brush over the paper and shaping the area of color as if filling in a drawing, extending the paint to the outline. For intricate areas where the hair of the brush is too thick, the color can be spread with the handle of the brush, which is impossible to do when painting wet on wet. This basic approach can be complemented with similar procedures (illustrated here), among which are removing wet paint with a clean and dry brush. The latter creates an area of lighter color, which can even become completely white if the color is removed in its entirety.

4

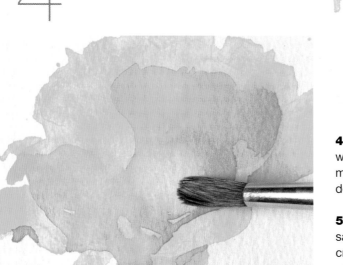

4. With the brush charged with just water, we create a highlight in the middle of the flower where the internal details can be painted.

5. The contrasts between the various saturations of the same color have created the realistic effect of this representation executed with the wet-on-dry technique.

5

the unpredictable effect of the water is emphasized when the work is carried out wet on wet, that is, with color brushstrokes applied over areas that are still wet. Now we will understand why the paint on wet is more watercolor-like than painting on dry paper. On dry, the results are crude, static, and lacking atmosphere, and are somewhat reminiscent of children's painting. On wet, things change: the colors become a layer of mist, a surface that evokes depth, imparting a characteristic "look" to the work.

working Wet
on wet

THE RESPONSE OF COLOR APPLICATIONS

We take the wide brush with natural or synthetic hair and we spread the extremely diluted color, that is, very soft and transparent, over a large area. We should not overwork or soak the paper; it is enough to apply an even layer with a few brushstrokes. If the water does not puddle up, we can apply a new layer of darker color obtained from mixing two paints (yellow and violet, for example) using a round brush. This last layer will spread very easily and will produce watermarks and unpredictable effects full of interest, if we know how to leave them untouched. It is all a matter of controlling the amount of water the brush is charged with, a control that is quickly acquired with practice.

Painting on wet is also more "picturesque" than painting on dry. Colors mix in with one another, giving way to unexpected nuances and combinations.

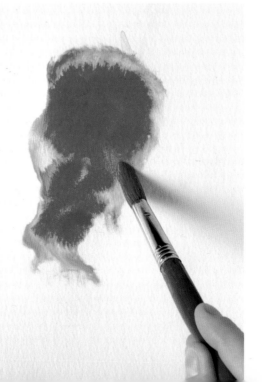

1

1. The first color is applied with a lot of water and also with much paint to create a generous expansion of color.

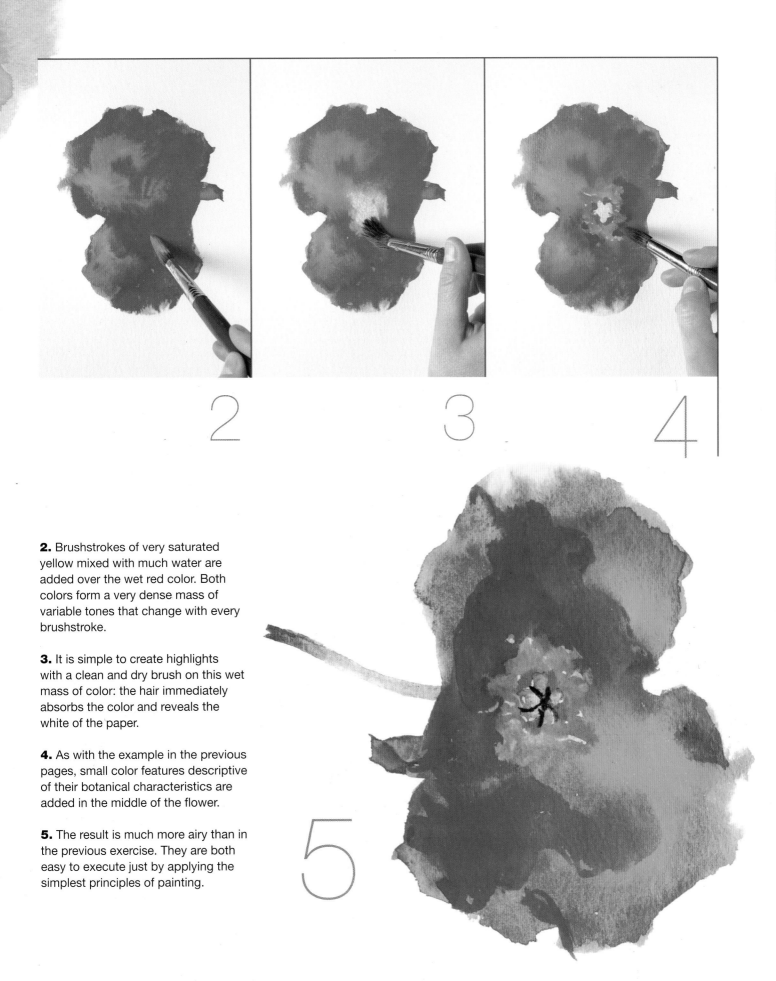

2. Brushstrokes of very saturated yellow mixed with much water are added over the wet red color. Both colors form a very dense mass of variable tones that change with every brushstroke.

3. It is simple to create highlights with a clean and dry brush on this wet mass of color: the hair immediately absorbs the color and reveals the white of the paper.

4. As with the example in the previous pages, small color features descriptive of their botanical characteristics are added in the middle of the flower.

5. The result is much more airy than in the previous exercise. They are both easy to execute just by applying the simplest principles of painting.

direct Mixing
on Wet Paper

1

1. This apple has been created following the same procedure described in previous pages for the red flower. Even the colors are the same in both pieces: red and cadmium yellow. Both are applied wet on wet from the beginning.

2. The yellow areas lose their definition when they mix with the contiguous red paint. The idea is for the colors to spread somewhat spontaneously to create an interesting artistic effect.

When we paint with watercolors, the paints can be mixed in two ways: on the palette or directly on the paper. In the first case the resulting tone is even, more or less saturated depending on the amount of water used. In the second, one paint is applied over a different one that we had previously applied and that is still wet. The result is much less homogeneous and quite a bit more unpredictable: it depends on the amount of water in the first color, its saturation, and the concentration of paint in the new application with the brush. Watercolor artists prefer the second option.

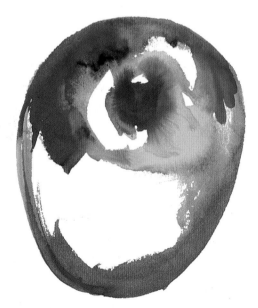

2

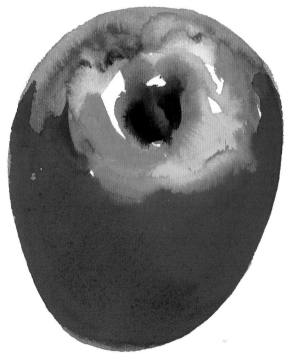

3

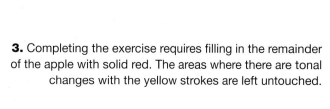

3. Completing the exercise requires filling in the remainder of the apple with solid red. The areas where there are tonal changes with the yellow strokes are left untouched.

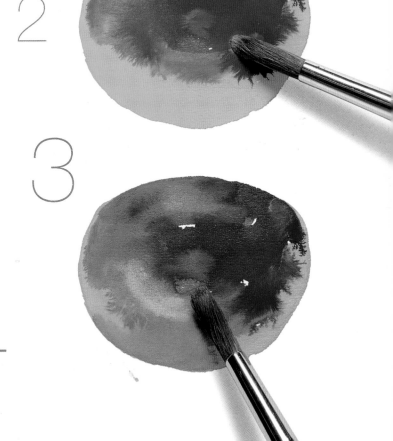

WATER, PUDDLES, AND NUANCES

A watercolor whose colors are consistent and uniform may be a beautiful architectural illustration, perhaps even a technical masterpiece, but we are often more attracted by a sensual and painterly image. This is achieved by mixing the paint directly on the paper; the surfaces show the marks of water, color bleeding, puddles, and various other nuances due to the fluid dynamic of the paint. This does not mean that this technique must be used systematically (nothing should be systematic in matters of art), but only when required by the theme and never in every square inch of the painting.

1. This tomato can be painted the same way as the apple. Two different colors (yellow and Hooker's green) will be used here.

2. The green is applied with a lot of both pigment and water while the yellow is still wet. That is why the colors are mixed together in the central part of the object.

3. The green is worked wet on wet by applying the clean brush in some areas to reduce the intensity of the color. The mixture of yellow and green that becomes a greenish ochre tone has resulted somewhat by accident and somewhat by the action of the brush charged with green over the yellow area.

4. The changes of tone and bleeding of the paint effectively suggest the tone of this tomato and express its rounded shape and volume.

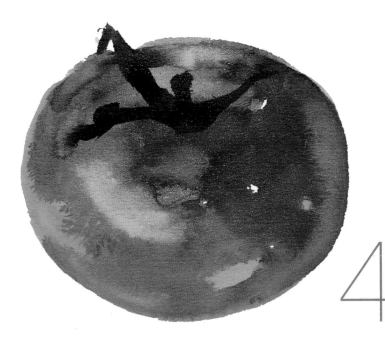

A basic Look
at Watercolor Subjects

as long as the ideas and resources we have studied up to this point have been properly assimilated, it is possible to begin painting without making any further arrangements. Any subject is suitable if there is appropriate planning: simplify to the maximum, reduce the mixtures on the palette to a minimum, and make the brushstroke count when it comes to defining the forms. Even shortcomings in drawing can be compensated with a spontaneous control of the brush.

This scene has been approached with such freedom and freshness that lack of accuracy and precision in the drawing and the color matter not at all. The artistic resources are very basic but they have been well distributed. Work by María José Roca.

DRAWING AND COLOR

The question of which type of drawing is suitable for painting with watercolors will be addressed in later chapters. For the time being, it is important to know that an elementary, sketchy drawing created with a very diluted form of one of the colors that will be included in the work, is sufficient. The drawing in question will end up being completely integrated into the painting if it has been made with the tip of the brush and without excessive detail. Remember that any brushstroke constitutes a form and a color of the composition and that, in the end, differentiating drawing from color too much will produce static and unnatural results.

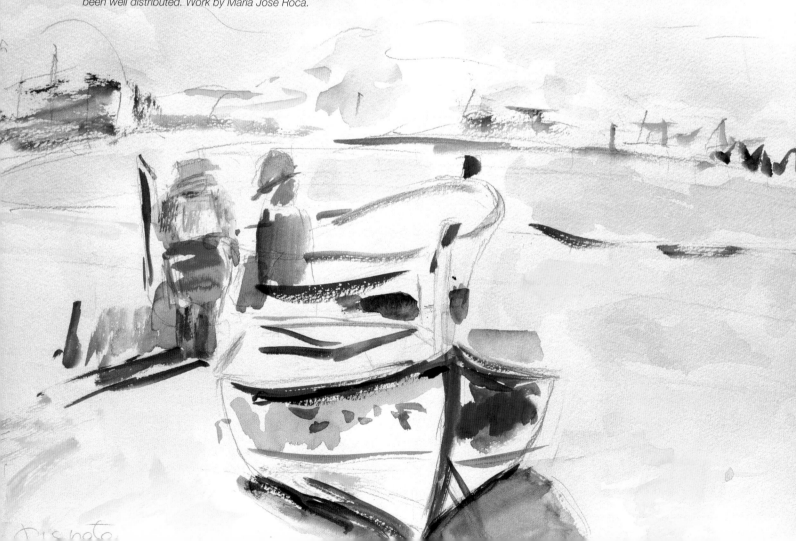

The color of these plums has been achieved by mixing quinacridone carmine red and ultramarine blue. Both colors are applied liberally, letting one or the other dominate depending on how the painting develops. In general, red is the dominant color, never in flat strokes but rather very defined through several applications of water.

The notes or studies with watercolors do not require any special technical preparation. Applying the basic principles studied until now is sufficient to achieve stimulating results.

As far as the drawing for a watercolor, a few lines sketched with the basic color of the painting are enough. These lines will later be completely integrated into the picture until they become imperceptible.

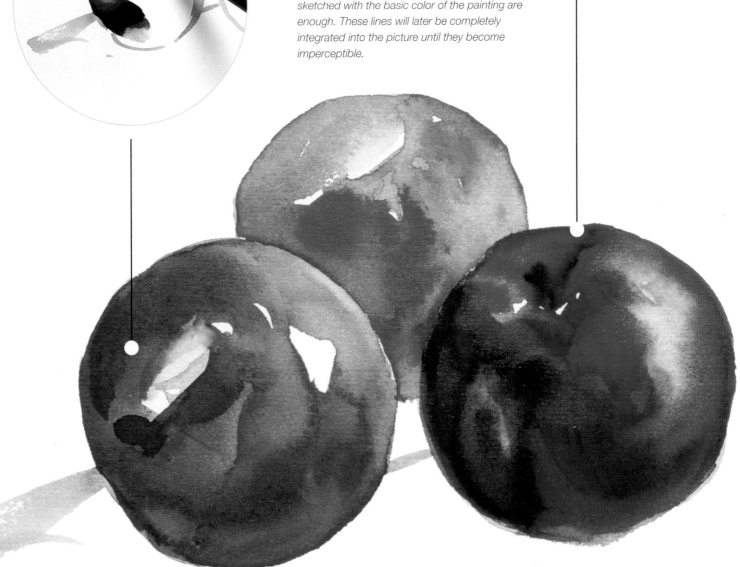

An
introduction

DAVID SANMIGUEL. HORSES, 2004.
WATERCOLOR

to color.
Watercolor painting
requires the artist

to put many different resources to use according to his or her talent and experience. None of them is as relevant as color. Watercolor painting exists thanks to color, and without it there is little left. But color is not a factor that can be solved once and for all, nor does it have a unique and well-known recipe for its application; on the contrary, it is the result of a creative and technical process that pursues the delicate balance of the parts for the benefit of the whole. This benefit includes the total chromatic harmony, the intimate relationship between form and stroke.

The contact with color:
Simple Monochrome

the monochromatic approach, also called wash, is the best way to start out with watercolors, the simplest and most effective way to get acquainted with the medium and to understand its peculiar dynamics. It is a painting based on a single color obtained from a single paint or the mixture of two or more paints. In these pages we show how to work with a single color: Payne's gray (a mixture manufactured from black pigment and ultramarine blue). This paint is quite dark to begin with and allows a very wide, clean, and defined range of values of each one of its intensities when diluted with progressively larger amounts of water.

STROKES, FORMS, AND LIGHT

A watercolor painting, in its pure state, is formed exclusively of direct strokes that simultaneously represent the subject's form and light. The artist "draws" the form and the light with the tip of the brush, controlling the solution of the paint as the work progresses. The saturation and smoothness of Payne's gray provides great purity and graphic definition to the strokes, which isolates this monochromatic approach from other typical factors of watercolor, which we will study later. In addition to watercolors, we must always have a sheet of paper available to test the intensity of each paint application before using it on the work. It is also vital to have a rag or blotting paper to remove the excess water from the brush.

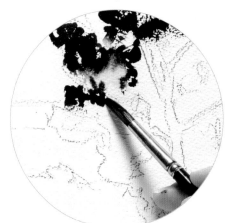

This gray, barely undiluted, is almost black, although its blue undertone is very obvious, whatever its level of saturation.

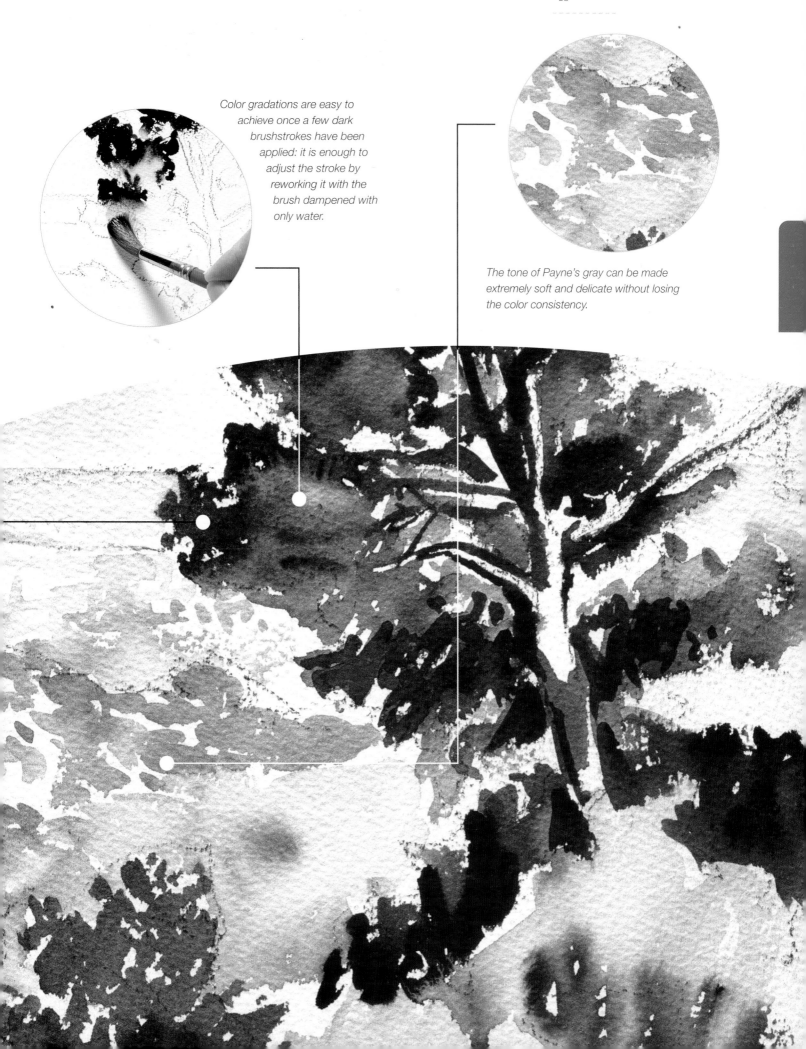

Color gradations are easy to achieve once a few dark brushstrokes have been applied: it is enough to adjust the stroke by reworking it with the brush dampened with only water.

The tone of Payne's gray can be made extremely soft and delicate without losing the color consistency.

Sepia (a very dark brown) is the traditional color for washes and monochromatic schemes. It is easy to produce a similar tone by mixing ultramarine blue and burnt umber. The advantage of the mixture versus the single paint is the increased richness and the variety of colors, which, based on a homogeneous mixture of gray tones, change into blues or browns depending on the greater or lesser amount of one color or the other in the mixture. With this, we introduce the study of new factors typical of watercolors, in addition to the strict process of controlling the intensity of light and dark values.

The contact with Color:
combined monochrome

WASHES AND COLOR SEPARATION

The watercolor artist never works the color, instead he limits himself to applying it to the paper, letting the dynamic of the water, the vehicle (gum arabic), and the pigment do the rest. Chance plays an important role, but the artist is already aware of this fact and is able to stage it or to promote its effects. Hardly any watercolor mixture, when it is very saturated with water, produces an area of color whose tone is completely even; one of the colors is always very active, more fluid, more opaque, more textured, or heavier. This produces washes, puddles, and visible color separations when the colors are dry. These effects can enrich the chromatic result if they are limited to a few areas of the work or they can ruin it if they extend over the entire surface.

Combined monochromatic schemes can be created with any color pairs as long as one is cool and the other one warm. But the pair that offers the best results is the one formed by ultramarine blue and burnt umber (in the center of the image).

These colors have been created with extremely diluted ultramarine blue. This area has been done first.

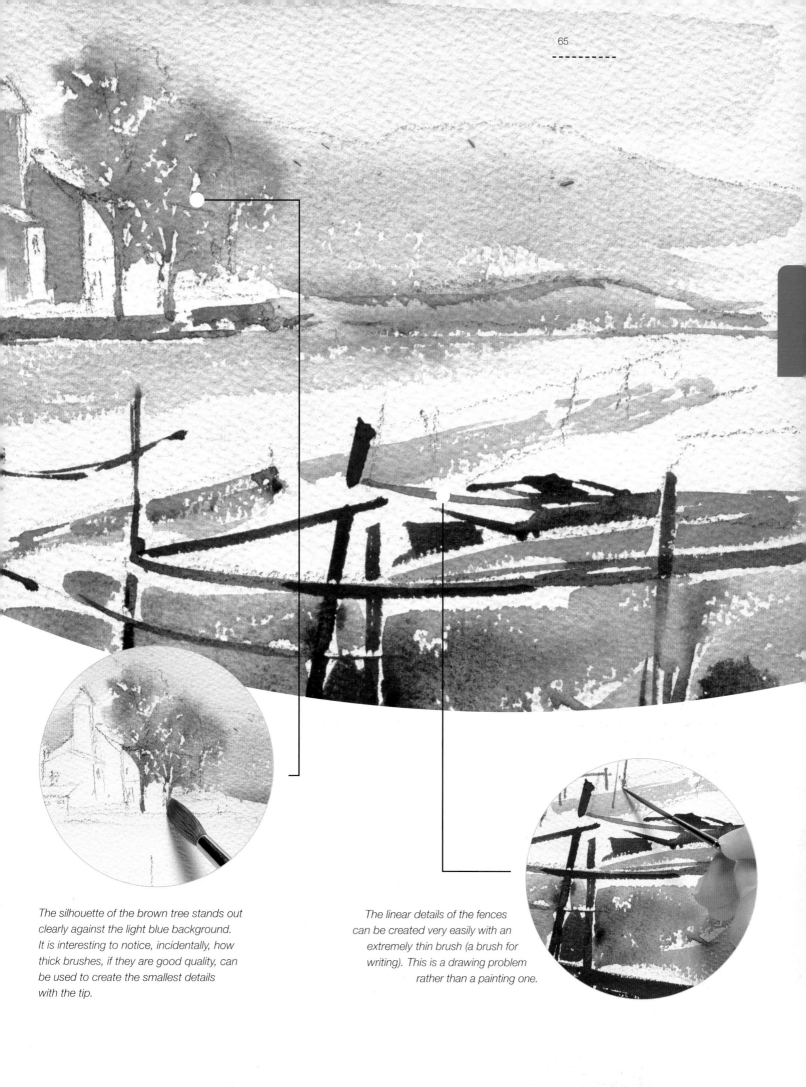

The silhouette of the brown tree stands out clearly against the light blue background. It is interesting to notice, incidentally, how thick brushes, if they are good quality, can be used to create the smallest details with the tip.

The linear details of the fences can be created very easily with an extremely thin brush (a brush for writing). This is a drawing problem rather than a painting one.

Watercolor with just Two
Contrasting Colors

the most practical and efficient way of approaching the color component of a watercolor is to limit the palette to the bare minimum. We have already seen that when we work with a monochromatic scheme, one dark color may be sufficient to create wider chromatic nuances by defining the different light and dark values. Using two very contrasting colors does not present any additional problems and makes it possible to achieve results that are very colorful. The colors can be chosen by affinity: colors that allow moving from one to the other easily, maintaining the harmony within the same range. These pairs can be yellow-red, yellow-green, green-blue, and red-blue. The yellow-green pair has been used for the exercise presented on these pages.

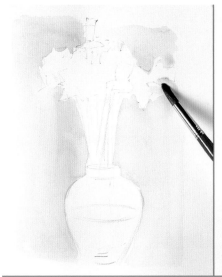

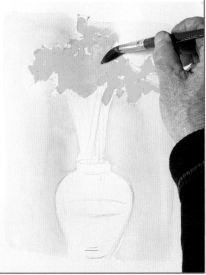

1

2

1. The simple vase with flowers shown in this exercise is left unpainted in its entirety while a very light blue wash is applied. The shape had been laid out beforehand with a simple pencil sketch.

2. The flowers are painted dry over the area reserved for them. Cadmium yellow, quite saturated, is used. The light areas are "washed" with a brush wetted with just water to reduce the color.

3. The green is a mixture of the same yellow and cerulean blue. The stems are painted with this green, as are the reflections on the glass vase. These reflections are very wet areas of color to which we have added small amounts of color to change their tone as it is applied to the paper.

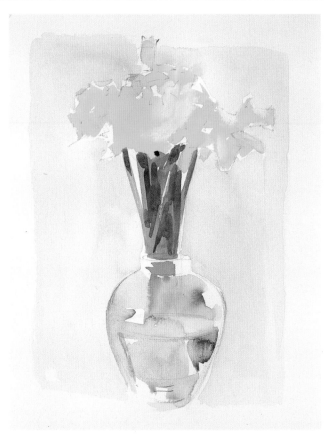

3

THE ORDER OF WORK

In watercolor we suggest working from light to dark. This is not a required approach, but it is easier for a beginner to darken the color progressively than to lighten it with techniques that force him or her to correct what has been done already. The flowers in this exercise can be resolved by painting with medium cadmium yellow and cerulean blue only. The mixture of both colors provides a very wide range of yellow greens; the different mixtures of paint widen the tonal spectrum even more.

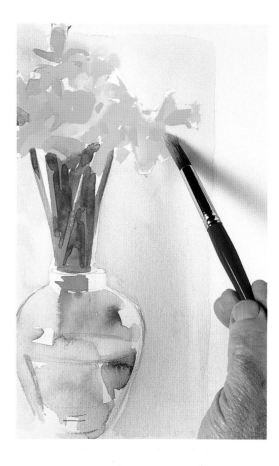

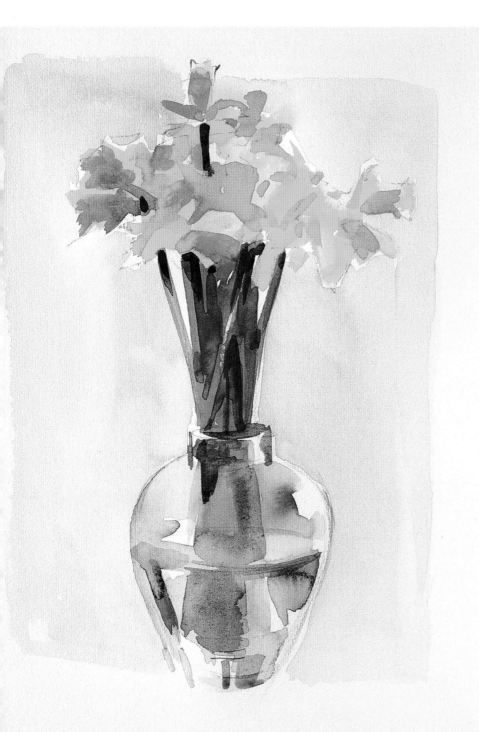

4. Touching up with dry brush. Small details that continue to shape the flowers and that overlap, with the darker color, the previously applied areas.

5. The result is a painting that looks elaborate but that has been created following a simple process. Just two colors were enough to develop the luminous range displayed in the final painting.

The entire subject is "drawn" as if it were one compact mass using a very diluted green color and a flat brush. This area of color provides a perfect guide to begin the work in a conventional manner: it creates a mass that contains everything.

Color
and brushstroke

One of the great advantages of watercolors is that the results can be seen immediately. The brushstrokes maintain all their freshness and form part of the play of shapes in the work, to the point that the objects represented can totally be identified by them, a little bit like Japanese washes, where the grass, the feathers, the rocks, the clouds, and all the objects are brushstrokes applied in special ways. Rather than going to the degree of Oriental stylization, modern watercolor artists like to preserve that spontaneous freshness in their finished work.

THE OBJECT'S SHAPE
AND THE PATH OF THE BRUSH

For an experienced watercolorist, it is commonplace to describe the shapes of the objects directly with the brush. The opposite approach would be drawing the subject and filling in the spaces with different colors. It is important to acquire the habit of synthesizing from the beginning, even if it is difficult to control the shape (that is, the brushstroke) and the result is not a perfect drawing. An initial sketch can be made as a guide that gives an approximation of the subject, using a very diluted and almost imperceptible color. This preliminary guide will provide an outline of the forms so the colors can be applied over them with firm brushstrokes.

The color of the initial layer is so light that it does not obstruct working with the paint. Orange is applied over the previous layer to depict the carrots, using a mixture of burnt sienna and cadmium lemon yellow.

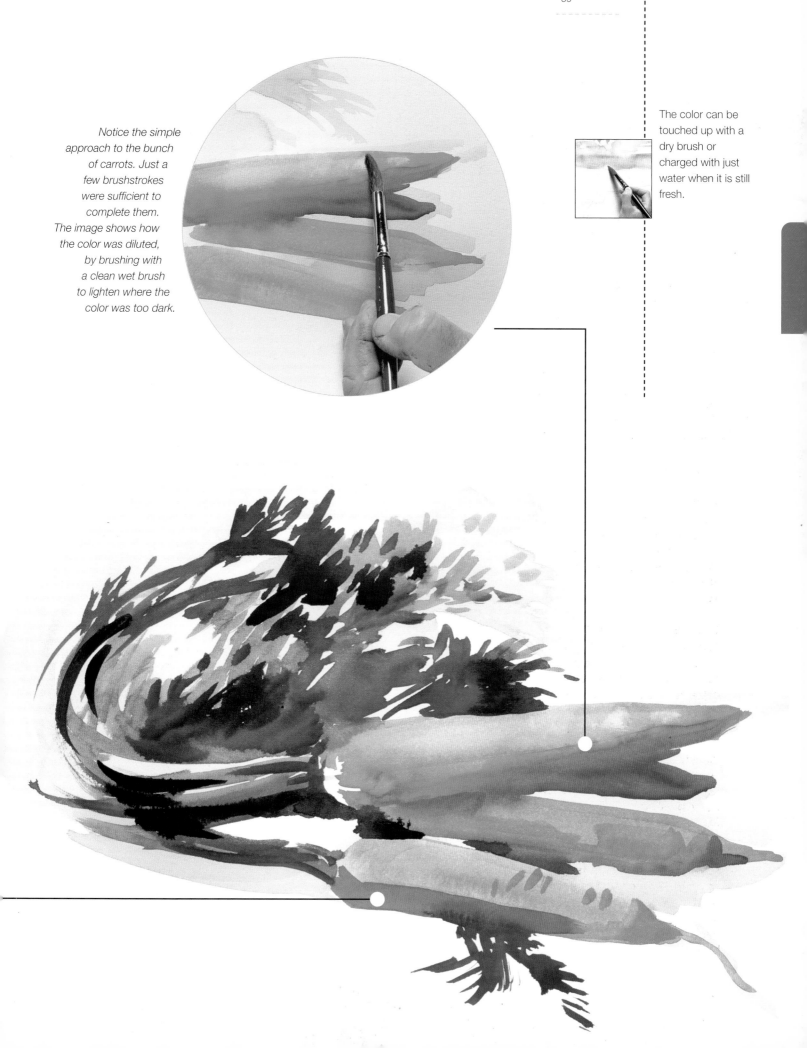

Notice the simple approach to the bunch of carrots. Just a few brushstrokes were sufficient to complete them. The image shows how the color was diluted, by brushing with a clean wet brush to lighten where the color was too dark.

The color can be touched up with a dry brush or charged with just water when it is still fresh.

Using the White
of the paper

2

the watercolor tradition prohibits the use of white paint. For now we will not discuss whether this is a good idea or just prejudice; let us say only that from an academic standpoint it is more interesting not to use it. White color can be represented in the painting only by areas of the paper left unpainted or with a simple glaze. This means that when the subject we are working on has objects or areas that are completely white, we will have to be careful and observe the silhouettes of such areas or objects without invading them with paint. We will be able to touch up, define, or glaze over those whites only at the end of the work.

1

1. A simple bouquet of white roses: from the beginning the silhouettes of the roses appear by contrasting with the blue background (very diluted) that extends through the entire composition. The silhouettes must be somewhat large and simple in shape for the reserve to be easy to work with.

2. The inside of the reserve can be defined (with the same blue from the background) so it does not end up being completely flat white. These small areas highlight the white flowers.

3

RESERVES

The technique for making a reserve consists of leaving the areas unpainted, "cutting them out" from the rest of the composition. When making a reserve, the watercolor artist draws the contour of the white object by painting around it. This is not difficult to do as long as the objects are sufficiently large to make the reserve comfortably. When the reserve to be created is very small, the artist can choose to apply white wax (like the crayons used by children) before beginning to paint; the wax repels the water and the area remains white. Other options are liquid gum (a liquid rubber that is uncomfortable to use), or the forbidden white paint.

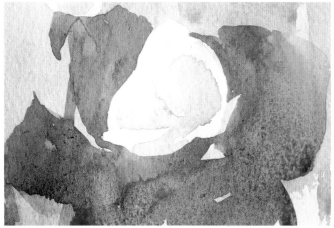

4

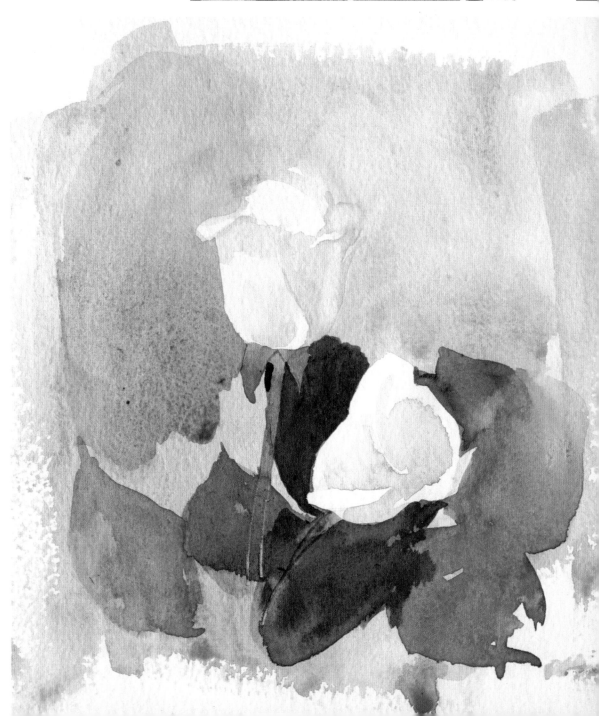

3. The leaves are painted very simply (with Hooker's green), highlighting their characteristic shape and avoiding the reserves made around the flowers.

4. Finally, a few of the leaves are darkened so the group acquires a little bit of volume and three-dimensionality. The contours and the interior shape of the roses are perfectly defined with few (very few) applications of color.

Drawing
Techniques
and
color harmony

"DRAWING IS NOT ONLY CREATING OUTLINES, DRAWING DOES NOT SIMPLY
CONSIST OF LINES, DRAWING IS EXPRESSING THE INTERNAL FORM OF THE
PLANES, OF THE MODELING."
J.A.D. Ingres.

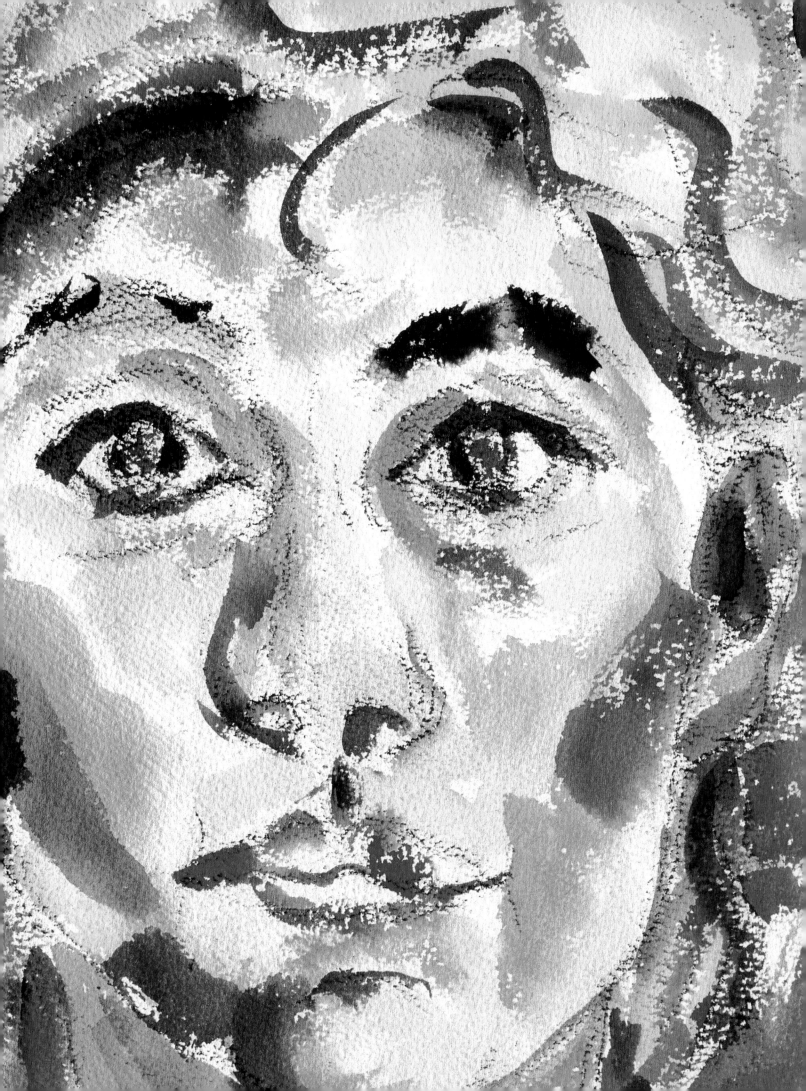

The
Watercolorist's

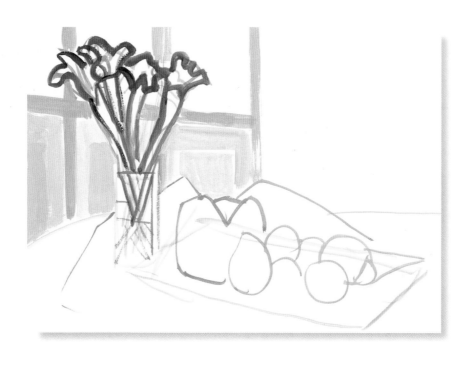

drawing.

In a book
devoted to watercolor technique

there is hardly any room for detailed explanations about the general principles of drawing, and it is obvious that a minimum knowledge of drawing is necessary for any watercolor artist. What follows, therefore, are explanations of how the criteria for drawing have been applied in a general sense to the problems of painting watercolors. The basic idea to keep in mind is that the simplicity of watercolors gives priority to color and its application; line is also important, but it must always be relegated to a discreet second level.

Drawing technique
previous to Beginning the Watercolor

the preliminary drawing for a watercolor should be linear and should not have shadows or any other additions than those that are indispensable for defining the forms. A drawing sets the boundaries between the composition's planes and the basic outlines of the forms. Watercolor is a transparent medium, it does not conceal, it does not produce opaque areas of color, and it is very possible that the lines of the drawing will still be visible when the work is finished. If the artist shades the preliminary drawing with colors or with lines, the result will probably look muddy, because that initial shading will distort the colors. However, some artists do apply shadows to the preliminary drawing, but they are usually linear, resolved with lines and not blotches or diffused pencil or charcoal lines as is common in artistic drawing.

This image shows in full detail what the relationship is between the drawing and the color in a very suggestive unfinished work. The lines of the drawing, finely drawn with a hard lead pencil, approach the motif tentatively while the color concludes it with an array of tones that completes the forms. Work by Mercedes Gaspar.

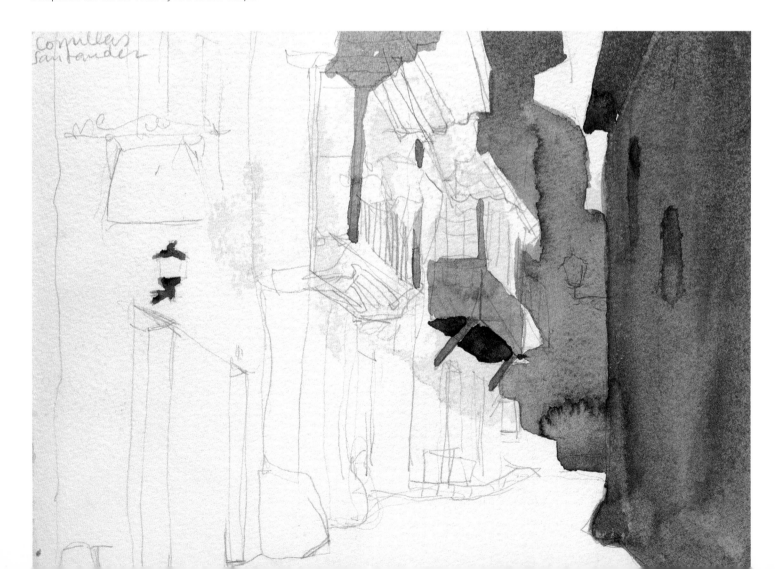

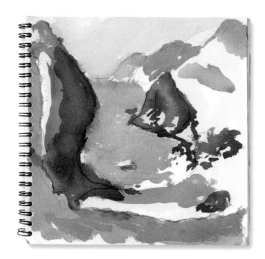

When the lines of the drawing are very thin they virtually disappear when the work is finished, mixed in with the features of the landscape and the outlines of the color areas. Even so, to achieve such a clean result it has been necessary to roughly lay out the masses that constitute the depicted subject. Work by Teresa Galcerán.

In watercolor painting, the drawing is almost always defined by the borders between the areas of color. These outlines can be very well defined or be mixed within the areas of color.

THE PENCIL'S HARDNESS

It is most common to draw with a soft graphite pencil (B grade) but many artists use a hard pencil (H grade) to prevent the lines from becoming visible in the final work, and they even erase the drawing partially before they begin painting. However, the lead of hard pencils is very sharp and can easily cause scratches and depressions on the paper; these depressions could retain water (and the paint in it) and would result in lines that were excessively visible at the end. Therefore, if a hard lead pencil is used, we must draw gently and apply barely any pressure.

Portraits are the type of subjects where the watercolorist must moderate the drawing so as not to overwhelm the physical appearance with exaggerated features. This is especially true when dealing with the portrait of a child, as is the case here, in which the delicate approach must be present in the final result. Work by Mercedes Gaspar.

Preliminary Drawing
with charcoal

1

Charcoal is not as common a medium as graphite pencil but it is equally suitable if used in moderation, without excessively muddying or scratching and without shading or blending. This is a medium that is recommended only for medium and large watercolors, where the heavy charcoal line does not create any problems. If conventional charcoal sticks are used, it is important to wipe off the paper with a clean rag when the drawing is finished to prevent the charcoal particles from dirtying the color more than is necessary. In any case, the artist who uses this drawing medium already foresees that the color will be muddied to some degree and counts on it for creating the mood for his work.

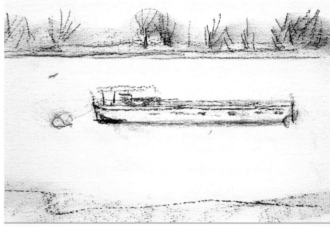

1. This drawing has been made with charcoal pencil in all or almost all the intensity allowed by this medium. It could seem that a watercolor could be ruined by the emphasis of the lines, but that is not the case; the lines become part of the color.

2. Very watery wash diluted with Payne's gray, which completely covers the drawing lines. They have been affected by the water, which in turn has been tinted with the charcoal particles.

2

3. The wash has to be allowed to dry before continuing. The reflections on the water of the river are but a few strokes of a very diluted earth tone. Notice that the barge has been left unpainted.

3

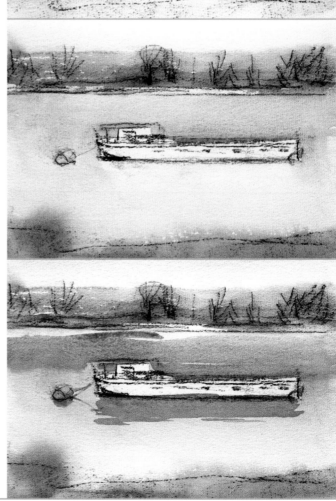

DRAWING WITH CHARCOAL PENCIL

This is an interesting alternative for small-format paintings. The charcoal pencil (sometimes called Conte pencil) leaves a darker and more permanent line than charcoal. This means that it should only be used when the artist is prepared to deal with the black lines of the drawing (which are impossible to conceal) until the completion of the work: the drawn lines form part of the painting. Illustrated here is a good example of this, and it is attractive enough to make trying this approach worthwhile.

4. A few dark accents are added to the barge and the watercolor is finished. The lines have been completely incorporated into the scene and do not obstruct the color at all. On the other hand, the color, which has been reduced to grays, goes very well with the black charcoal lines.

Some watercolor artists use compressed charcoal or charcoal pencils (both having a denser and more compact tone than charcoal) to highlight blacks. It is important not to mix these applications with water so the work does not get dirty. The most logical approach is to leave them unpainted or to draw them at the end of the process.

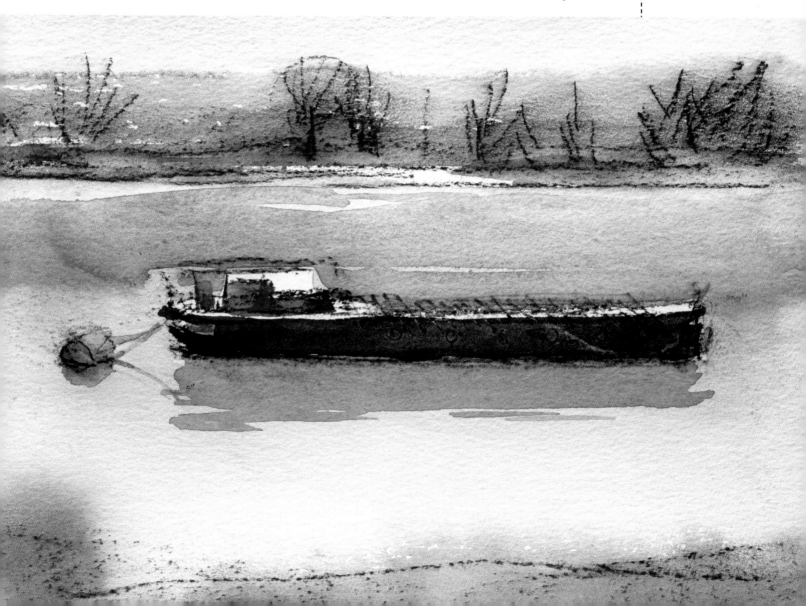

the Drawing as the outline of
Reserved Forms

We know that reserves, either white or of a color background, are a way to outline the edges of forms, that is, of drawing. In watercolor, forms are defined by the color that surrounds them. In fact, a good portion of watercolor painting is making reserves of different colors. Therefore, reserves require not only a talent for color but also mastery of drawing and a vision of the forms, since any form can be represented with a reserve, by simply painting its outline. These reserves can also have the purpose of creating contrasts: for example, darkening the banks of a river emphasizes the clarity and shine of the water. Continuing with this example, that same water can be created through a series of white reserves that express the reflections on the surface; several uncalculated reserves but created spontaneously during the process until an overall suppleness and natural feeling has been created.

DRAWING LIGHT FORMS

The reserve drawing is usually made of light forms that have to stand out against a darker background. The background color is the one that we use "to draw" around the subject. Once the reserve is finished we can paint inside of it, creating all the nuances of light called for by the model. This drawing requires experience and mastery: the work should be approached liberally and without hesitation. The outlines should be convincing from the beginning. The delicate elements and shiny nuances of the flowers that are represented here are the result of good preliminary reserve work.

Despite the various colors and shadows that crisscross this flower, the white reserves created at the beginning can be clearly identified. They form a truly luminous drawing that stands out strongly against the dark background.

The entire subject is approached with reserves — there are no preliminary lines but only contours and white silhouettes against a black background. This is not as difficult as it looks; the flowers provide enough margin of error; their outlines do not have to be exact to look convincing.

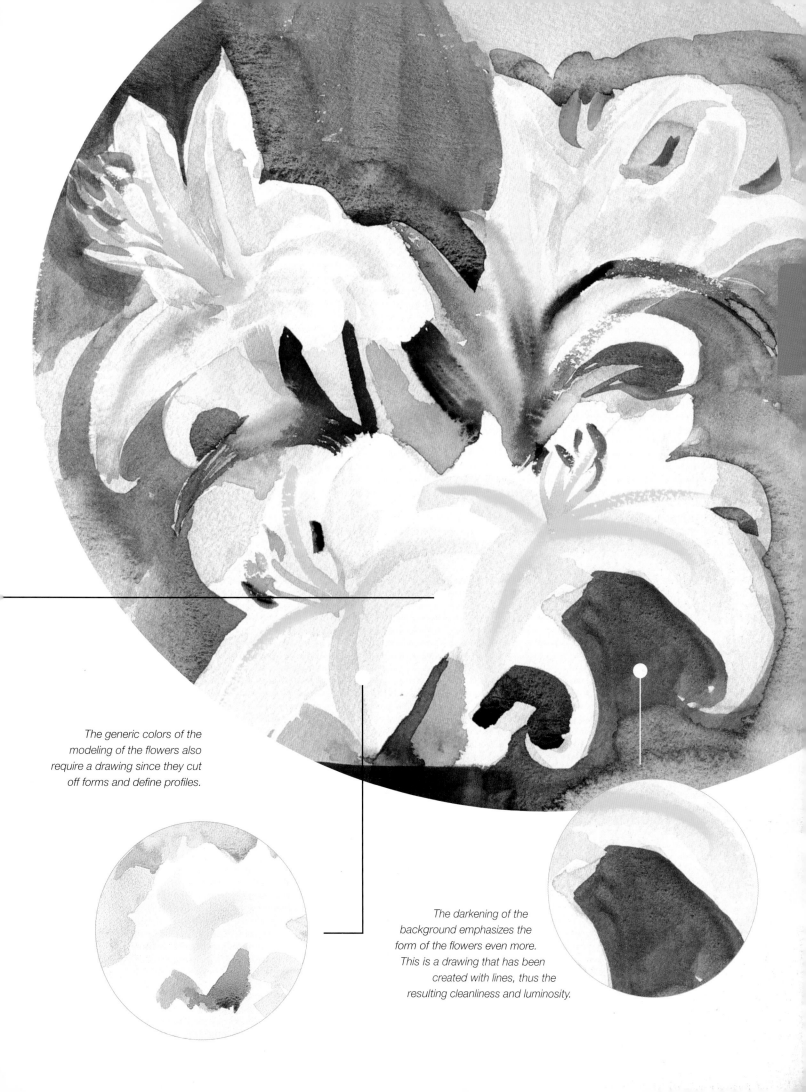

The generic colors of the modeling of the flowers also require a drawing since they cut off forms and define profiles.

The darkening of the background emphasizes the form of the flowers even more. This is a drawing that has been created with lines, thus the resulting cleanliness and luminosity.

In watercolor painting, the drawing can play a central role that goes beyond the simple preliminary drawing. Many painters make the drawing a very important part that is maintained throughout the work. It is a line that is often full of color, that varies its thickness and tone, and that acquires a life of its own.

Simultaneous
Drawing and color

Landscape artists like to combine the functions of the drawing and of color. The drawing does not encapsulate the forms. Instead it makes them mobile and vibrant, and color is not limited to "filling in" the spaces of the drawing, but it superimposes them, invades them, and creates chromatic changes and combinations. These artists modify the landscape while they create it, constantly correcting and modifying the drawing until the overall effect of harmony has been achieved.

DRAWING WITH A BRUSH

Another common medium is drawing with the tip of the brush, which is charged with a very diluted color (a light blue or gray). This approach to drawing leaves scant room for details and is used by those artists who do not need to have an exact compositional layout before they begin to paint. It is important to keep in mind that the lines of this drawing can very well acquire an artistic role and have different colors according to the area or the object being drawn. This is a suitable drawing approach for large formats, where the brush can be handled freely and without obstacles.

It is impossible to know where the drawing begins and where the painting ends. From the beginning, both factors are used simultaneously to create the portrait.

Painting and drawing are the same when working in a style where the line of the brush is as important as the application of color. The drawing is always in color, and the color always has a brushstroke rhythm.

This interpretation of an interior in "abstract" form is an extension of the linear rhythm created by the windows and the rest of the elements of the scene. In works like this one, line and color go hand in hand.

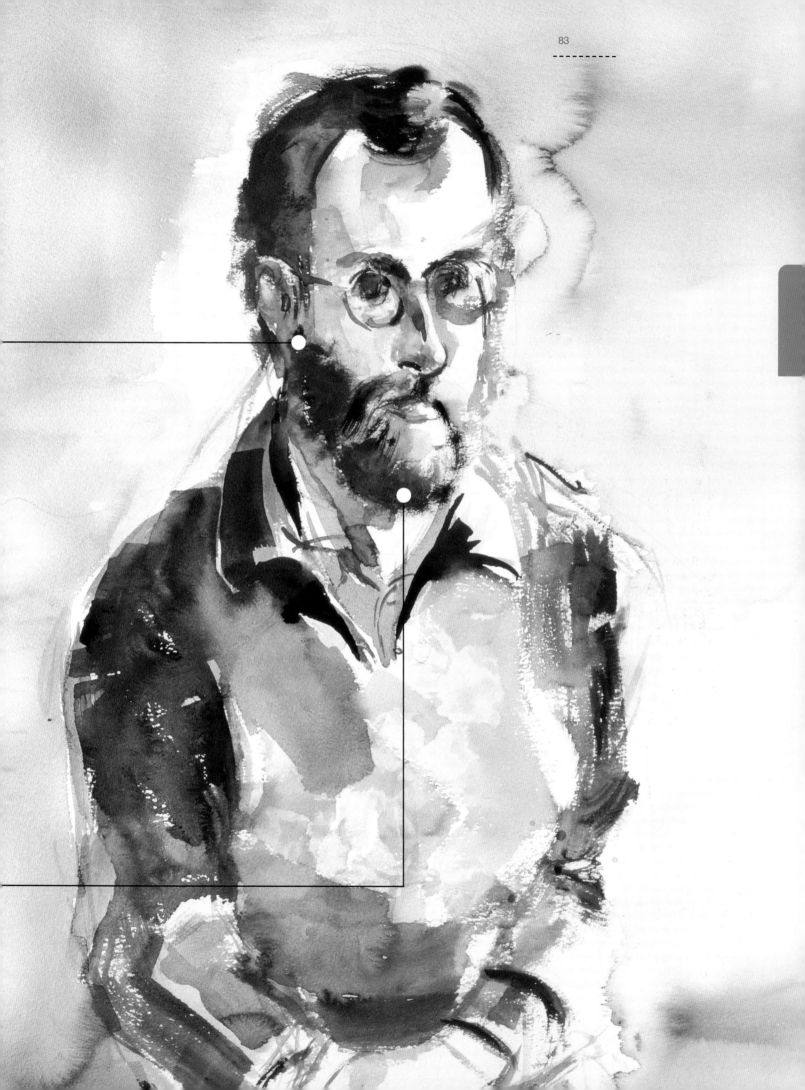

the Brushstroke
as Drawing

the color brushstroke is the synthesis between drawing and color, and it constitutes a distinctive and essential factor in watercolor painting. The color brushstroke has its own shape, that of its outline, and it can also be suggested with different paint intensities. Da Vinci's advice to painters was to observe the water stains on old walls to discover in them faces, figures, animals, landscapes, and every kind of scene: the mind completes that which appears suggested in a random configuration. The power of suggestion of color brushstrokes is incomparable and it carries a complete idea of the object represented. This is something that the watercolorist can develop to the extreme, since the watercolor stain has unique and incomparable qualities: the mark left by the brush on the paper, the texture of the paper, the accidental variations in the intensity of the color, and so on.

The greater or lesser saturation of color in the stains, its application on dry or on wet paper, the use of reserves to express the drawing…these and other resources can be applied to the quickest of watercolor sketches or studies. Work by Óscar Sanchís.

It is practically impossible to express more than one subject with fewer resources. Here, only one color has been used: ivory black. The drawing results from the outline of the color and also from the areas left unpainted; light and volume are the result of different amounts of water in various parts of the watercolor. Work by Mercedes Gaspar.

COLOR BRUSHSTROKES AND SKETCHES

Sketching with watercolors consists of laying out several areas of color that have a harmony of form, placement, tone, and the like, and that convey the subject's essential elements in terms of drawing and color. Very often, the drawing ends up being more interesting and pleasing when it is suggested with color areas applied spontaneously. An area of shadow, for example, can have as much effect as an object that is very well defined; what is truly important is for the overall effect to be suggestive and to convey the essence of the subject.

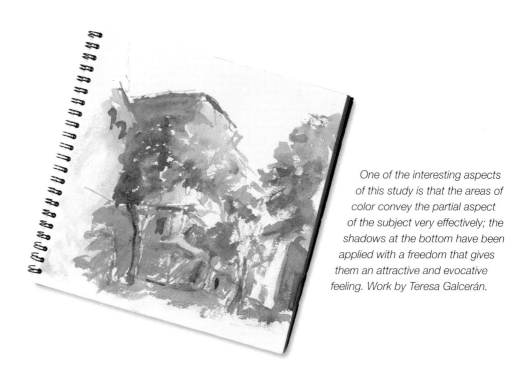

One of the interesting aspects of this study is that the areas of color convey the partial aspect of the subject very effectively; the shadows at the bottom have been applied with a freedom that gives them an attractive and evocative feeling. Work by Teresa Galcerán.

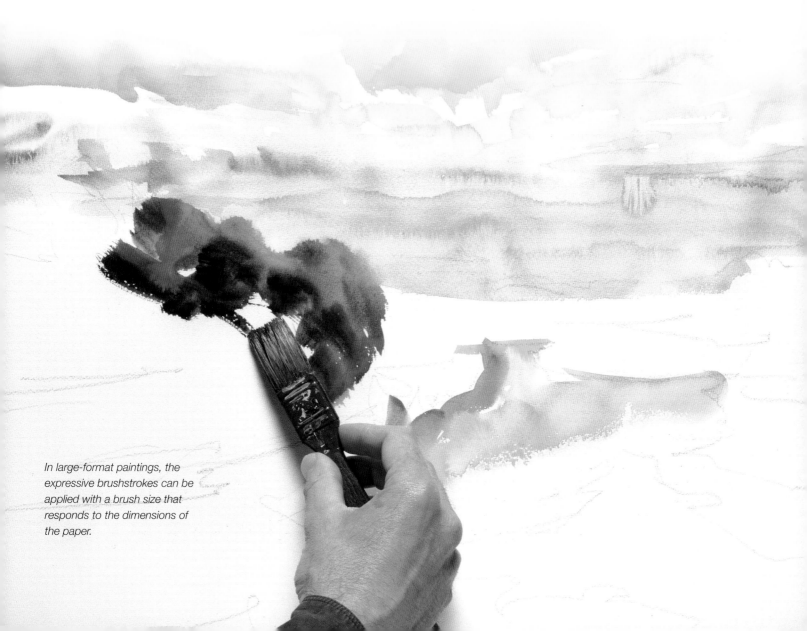

In large-format paintings, the expressive brushstrokes can be applied with a brush size that responds to the dimensions of the paper.

Line Drawing
and Blocks of Color

the drawing of a subject that is being painted with watercolors should not be too rigid, because that would remove spontaneity. It should not be a collection of enclosed and perfectly delineated forms either. We must be frugal: all that is well understood should not be overexplained, but only suggested with several indications here and there. The preliminary drawing in essence should invite color. The way to do this is by staying closer to a sketchy style rather than creating a drawing that is academically correct. In the simple exercise illustrated in the following pages we can observe a watercolor approach that is much like a spontaneous study, but that implies accurate observation of the animal that has been chosen as the model.

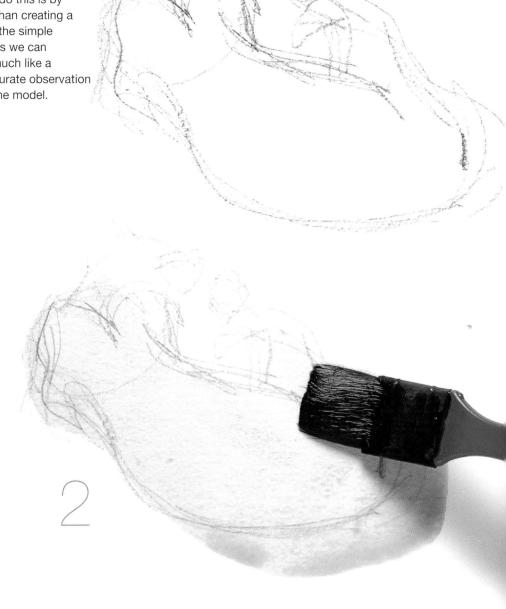

1

2

1. In this drawing we find multiple lines that create the contour more by trial and error than in an absolute manner. It consists of a comprehensive study of the form that leaves open the possibility of a new interpretation of the subject in terms of color. It would be a mistake to "fill in" this drawing with paint: paint must have its own channel within the general planning done in pencil.

2. Painting this cat can be entirely, or almost entirely, done with a single application of color. Now that we are familiar with its shape, we can work freely, letting the brush go (within limits). The color is a very diluted burnt umber.

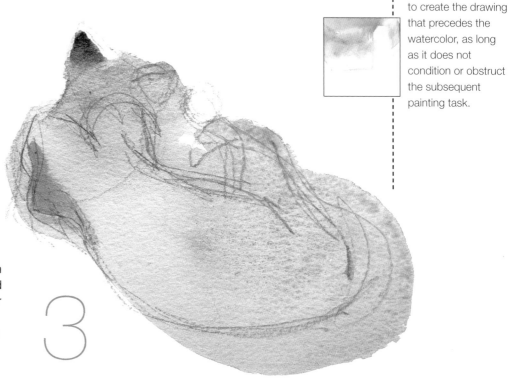

Any method is good to create the drawing that precedes the watercolor, as long as it does not condition or obstruct the subsequent painting task.

COLOR AND CONTOURS

The main reason why we absolutely advise against a drawing that is excessively finished in the preliminary stages of a watercolor, is that the interesting aspect of a watercolor's forms is when they coincide with the areas of color in such a way that the natural edges of the color and the form appear to be one and the same. A rigid drawing constrains the strokes of color and eliminates the expressivity of the watercolor. In this exercise we can see how the color extends far beyond the boundaries of the drawing to create a color edge full of freshness and visual charm. The interesting aspect is that the result is totally convincing when it comes to the representation of the animal. This means that the initial drawing must be revisited when the painting begins.

3. Although the color extends beyond the limits of the drawing, the silhouette of the cat is not only perfectly recognizable, but completely credible from an anatomical point of view.

4. A few additional applications of color (a mixture of burnt sienna and cobalt blue), painted wet on wet, are enough to complete the representation. The frugality of resources and the simple approach to the work are the main features of this beautiful watercolor.

The Harmony of

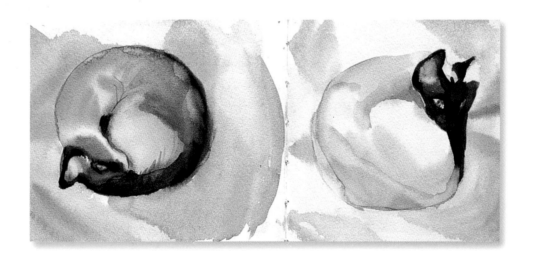

MERCEDES GASPAR. CATS. 2003. WATERCOLOR

Watercolors.
Each watercolorist
develops a color harmony

that is particular to him or her and that encompasses the array of possibilities of his or her own style. This harmony not only responds to an aesthetic taste, it also penetrates deep into the artistic mind of the artist, since it is the solution to his or her art's substantial problems: the representation of a visible piece and the inclination toward sensitivity. The following pages attempt to show how the harmony of the color extends its roots into the depth of a pictorial style.

Value and Color
Contrasts

We know that a monochromatic approach involves a single color in the process of making a watercolor. A monochromatic palette (also known as grisaille) is based on the contrast of light and dark colors (also called values). It is not necessary to use just one color to create a work with the tonal value approach; it is sufficient to limit the palette and to work with contrast between light and dark tones rather than contrast between different colors. These contrasts are the basis of color harmony because they provide an overall vision, not just the beauty of the colors themselves.

The tonal value approach is based on the interpretation of lights and shadows through gradations and the darkening of the tones: through chiaroscuro, which does not mean (as seen in these pages) that the results are dark and lacking luminosity.

COLOR HARMONY

To speak of color ranges is to speak of families of harmonic colors, colors that are not dissonant. A painting with a single color range can seem monotonous, but the colors never clash. Painters with a classical tendency usually work within one range, and then add some note of color that is different from that range to create a more lively composition.

All colors can be grouped into the following three ranges: warm colors, cool colors, and gray or neutral colors.

At the beginning of the work the theme is approached with a very soft wash of gray tones that leave the outlines of the table and the objects placed on it unpainted.

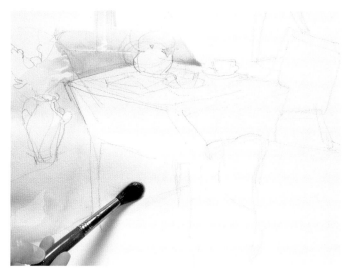

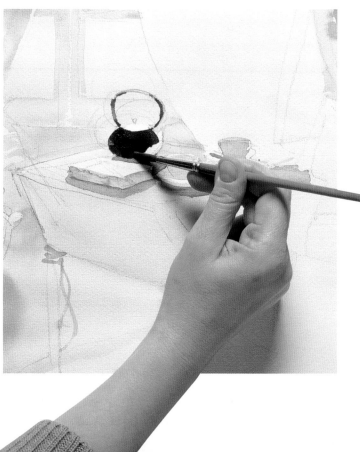

When very few colors are used (only two in this watercolor by Teresa Galcerán), it is more probable that the artist will achieve color harmony than when a range made of many contrasting colors is used. With a grisaille, everything lies within the contrast of value, of light against dark.

The shape of the teakettle is only a very dark silhouette. The effectiveness of the representation lies more in the value contrast (dark against light) than in the color.

Yellow and gray grisaille is alternated in all the areas of the watercolor, creating value contrasts. Here, the artist models the volume of this vase with a gray wash that creates a chiaroscuro effect.

The flowers are the only elements of pure color in the entire watercolor, a harmony that is based on contrasting values and grisaille rather than on contrasts of bright color.

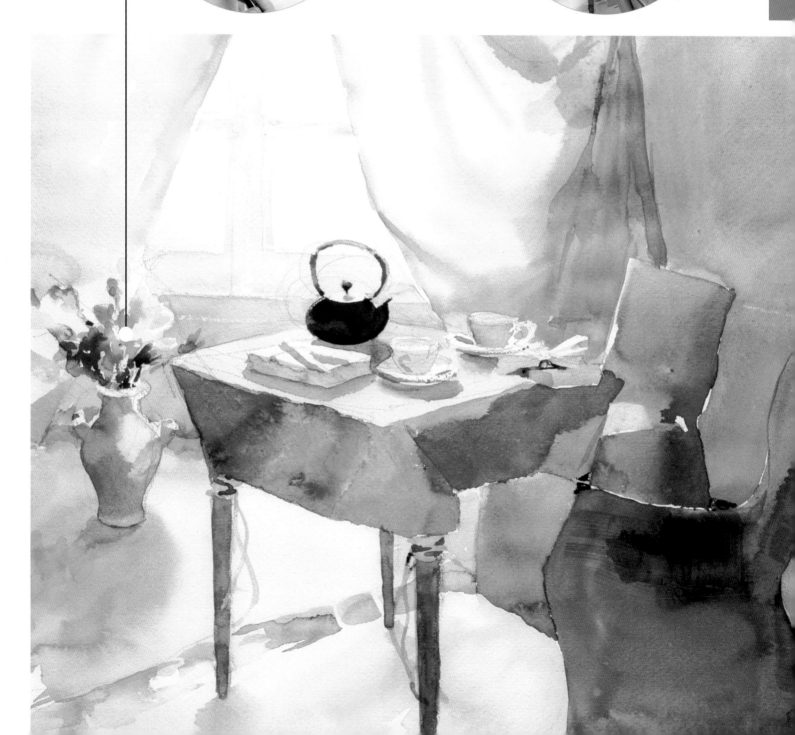

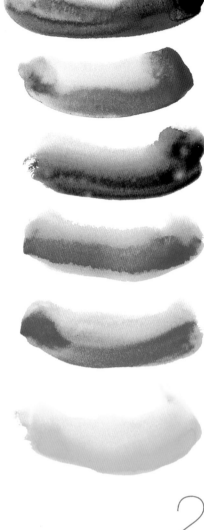

Warm and cool colors

the warm or cool sensations of color stem from obvious psychological associations. We call warm colors the tones of the earth, wood, skin, fire, and so on. The warmth of a color bears a relationship with the colors that surround it: the cooler the surrounding colors, the warmer the color in question will appear. Saturation also plays an important role. Warm colors look warmer if they are saturated and if they are not excessively bright. The psychological sensation of coolness is born from associations with water, the sky, metal, marble, ice, and other cool substances. Bright colors that are not very saturated always tend to appear cooler, especially if they belong to the range of blues and blue greens. Colors are perceived in relation to each other, therefore some cool colors may appear warmer when compared to others.

1

1. The vast expansion of the sky has been created by painting wet on wet: the many blue nuances are the result of the quick brushstrokes of the color being applied on a paper that is almost completely soaked in water.

2

2. Sienna has been applied wet on wet also; this is the reason for the different nuances that the color has acquired when painted over areas with different degrees of water. The darker values incorporate a small amount of blue.

3

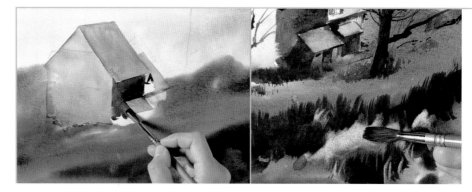

COOL AND DISTANT COLORS

Opposing cool and warm colors suggest a relationship of distance between them. In general, cool colors always convey distance with respect to the foreground of the painting. Impressionist painters exploited this phenomenon to eliminate the use of perspective from their work. They, as well as the painters who followed their teachings, understood that you only need to paint an object with a cool color for it to appear distant, and also for it to depict a shaded area in the representation. In the watercolor shown on these pages the division between warm and cool colors has been perfectly established by the horizon: warm colors appear in close range while cool ones are placed in the sky.

3. Warm and cool colors appear clearly opposed on the walls of the house. This warm-cool opposition further reinforces the light-dark contrast that gives shape to the volume of the building. To lighten up several excessively dark areas, whites have been created with a clean and wet brush.

4. In this landscape the colors are clearly divided into two groups: warm and cool. The warm colors occupy the entire surface of the ground and have been created with a reddish tone based on burnt sienna (very saturated in the dark areas and somewhat more diluted in the lighter areas). The cool colors are mixtures of violet and ultramarine blue.

4

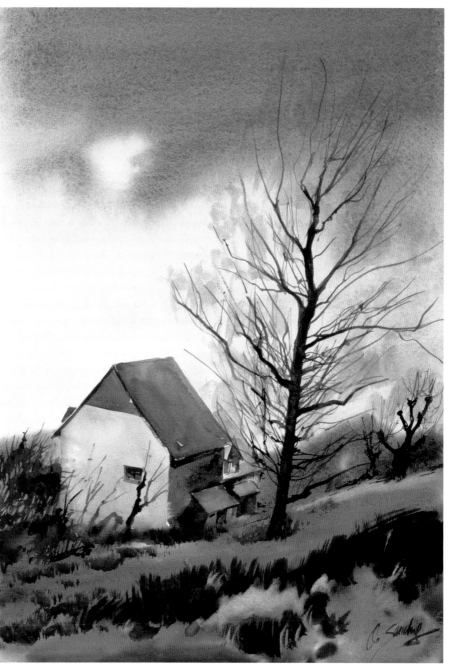

harmonious examples

even though every artist has strong ideas about color theory, none of them get their colors by mixing the three primary colors dictated by that theory. Instead they incorporate in their palettes all those tones that allow them to create the desired color results more easily, colors that they use in their pure state as well as mixed. One green cannot be substituted for another similar green, because the first one can produce good results in mixtures of light and vibrant colors, while the second one can be more suitable for creating darker tones. Personal taste for specific colors is a key factor when putting together a color palette.

THE PAINTER'S PALETTE

What a watercolorist generically considers "my palette" includes a varied selection of a number of colors that best adapt to his or her way of working. There are painters whose palette is light or dark, sparse or rich, light or powerful. The traditional, or classic, palette tends to be moderate, while an Impressionist or Expressionist painter favors a rich palette. The artist must choose a personal palette. Extroverted painters use a varied and abundant palette, especially if they like the intensity of light. A moderate and very orderly personality will have a tendency toward subjects and harmonies based on few colors.

Color and harmony are also present in the most moderate and simple watercolors. The subtlety of the colors (the large area that reflects the colors used) reflects a very personal and sensitive view of color. Work by Mercedes Gaspar.

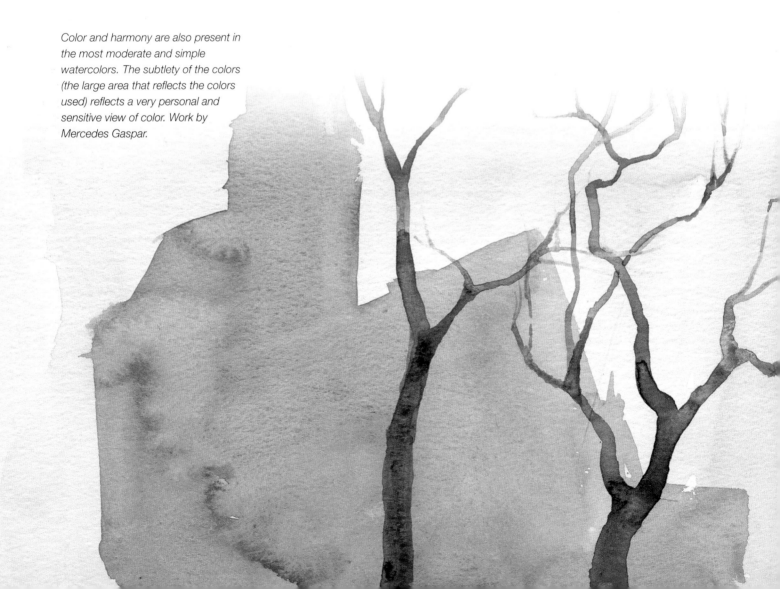

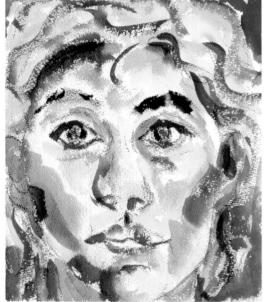

The casual and festive character of this work stems from the daring use of the most vibrant colors. The harmony is purely chromatic, leaving no room for tonal values and chiaroscuro. Work by Sara Lains.

The color harmonies of choice of a watercolorist become obvious by simply looking at his or her palette. Some palettes are true "abstract works of art" that clearly reflect the preferences of their owners. Naturally, the work has a structure and a direction that cannot be achieved on the palette.

This charming watercolor is very rich in details; however, its chromatic harmony is based on an uncommonly limited number of colors: blues, ochres, and siennas. The multiple combinations and mixtures greatly expand the range of colors. Work by Óscar Sanchís.

the Idea of
chromatic harmony

different subjects represent different chromatic harmonies. The color of a subject, especially if that motif is a landscape, is somewhat ambiguous and difficult to capture. It is quite difficult to be faithful to color. What a painter does is to develop an overall impression that he or she has made, an impression that is carried through during the working process. In this sense, painting is creating a harmony that captures and condenses different chromatic moments: pictorial harmonies are always inventions suggested and inspired by reality. If well constructed, they produce an unmistakably natural feeling.

WARM HARMONY

A warm harmony is created using colors that have red and yellow tendencies: orange, carmine, earth red, ochre, and so on, the range of warm colors. This range is natural in summer landscapes, in subjects bathed by sunlight, and in dry and rocky views. But it can also be an entirely personal option and independent from the subject, as can be seen in these pages and the following ones. In this range we can find endless different combinations that go from warmer to less warm, from the warm matte of ochre and earth tones, to the vibrant yellow and orange tones and the shadowy intensity of carmines. It is precisely with these last colors that we develop the warm range of the urban landscape illustrated in these pages.

This image shows perfectly a series of nuances that make up the dark areas of the range: chestnut, red browns, and green browns (resulting from the yellow). This heterogeneous and difficult mixture has made it possible to represent the treetop.

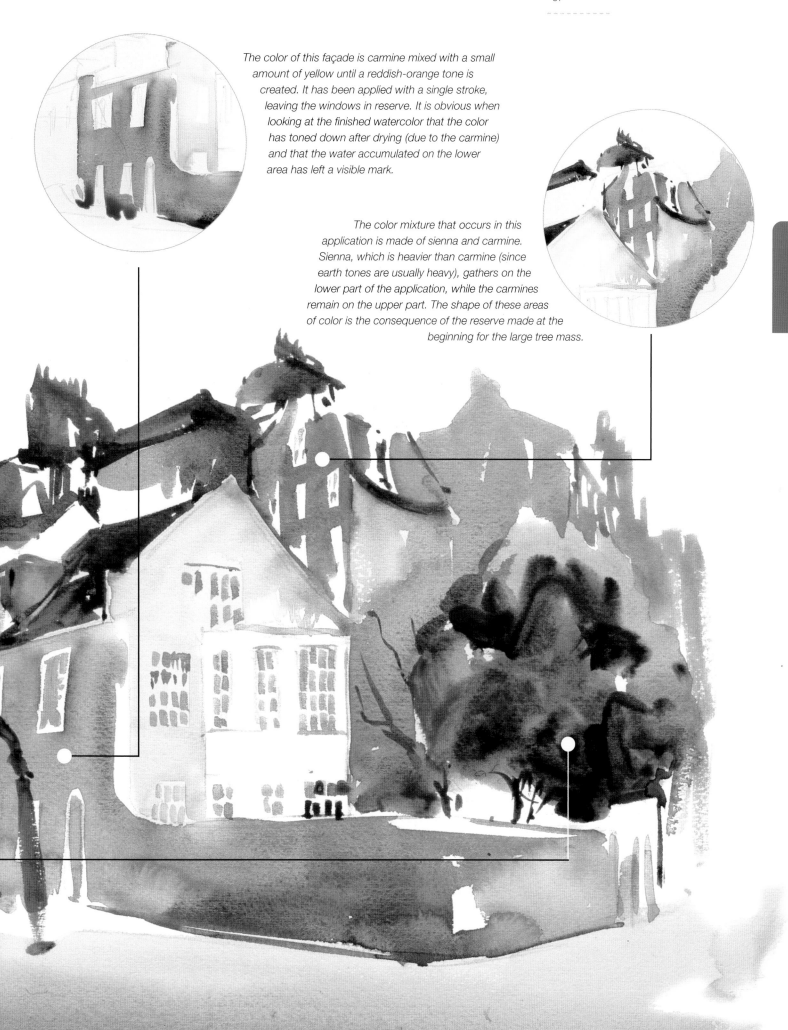

The color of this façade is carmine mixed with a small amount of yellow until a reddish-orange tone is created. It has been applied with a single stroke, leaving the windows in reserve. It is obvious when looking at the finished watercolor that the color has toned down after drying (due to the carmine) and that the water accumulated on the lower area has left a visible mark.

The color mixture that occurs in this application is made of sienna and carmine. Sienna, which is heavier than carmine (since earth tones are usually heavy), gathers on the lower part of the application, while the carmines remain on the upper part. The shape of these areas of color is the consequence of the reserve made at the beginning for the large tree mass.

Chromatic harmony
with cool colors

A cool harmony is made of colors related to blue and bright green; violets, green blues, emerald, turquoise, as well as grays that have a blue or green undertone. Yellow green is included in this range. When we talk about cool colors, we are referring to a large variety of colors governed by specific dominant colors, normally blue and gray. Blues can range from the lightest and most diluted to the soft and silky cerulean, to the deepest Prussian blue; grays can range from the silvers to the dirty and dark tones stemming from mixtures between complementary colors.

CHROMATIC HARMONY AND CHROMATIC TENDENCY

Every subject has a color tendency, be it warm or cool. However, it is very difficult, if not impossible, to find subjects that are made of tones belonging to one of these ranges only. The secret resides in the combination and contrast of tones. Therefore, in a work executed with warm colors it would be a good idea to introduce neutral and cool colors to emphasize the colors that are clearly warm. Within the neutral harmonies there is also a warm and cool tendency, otherwise we would simply end up with gray. The colors that make up the range used to create the urban landscape on the previous page are ultramarine, quinacridone violet, burnt sienna, and yellow: two cool and two warm. The latter two will always appear mixed together to create gray or brown nuances.

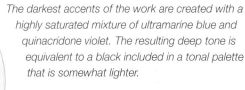

In this instance the tree has been painted with a mixture of ultramarine blue and a little bit of yellow, which is the color that brings out the green tint present in the finished work. The paint is quite dry, so the brush leaves marks on the paper. Although the brushstroke traces disappear when the watercolor is finished, we can see the clear presence of ultramarine separate from yellow.

The darkest accents of the work are created with a highly saturated mixture of ultramarine blue and quinacridone violet. The resulting deep tone is equivalent to a black included in a tonal palette that is somewhat lighter.

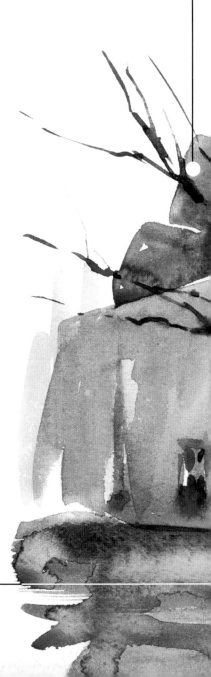

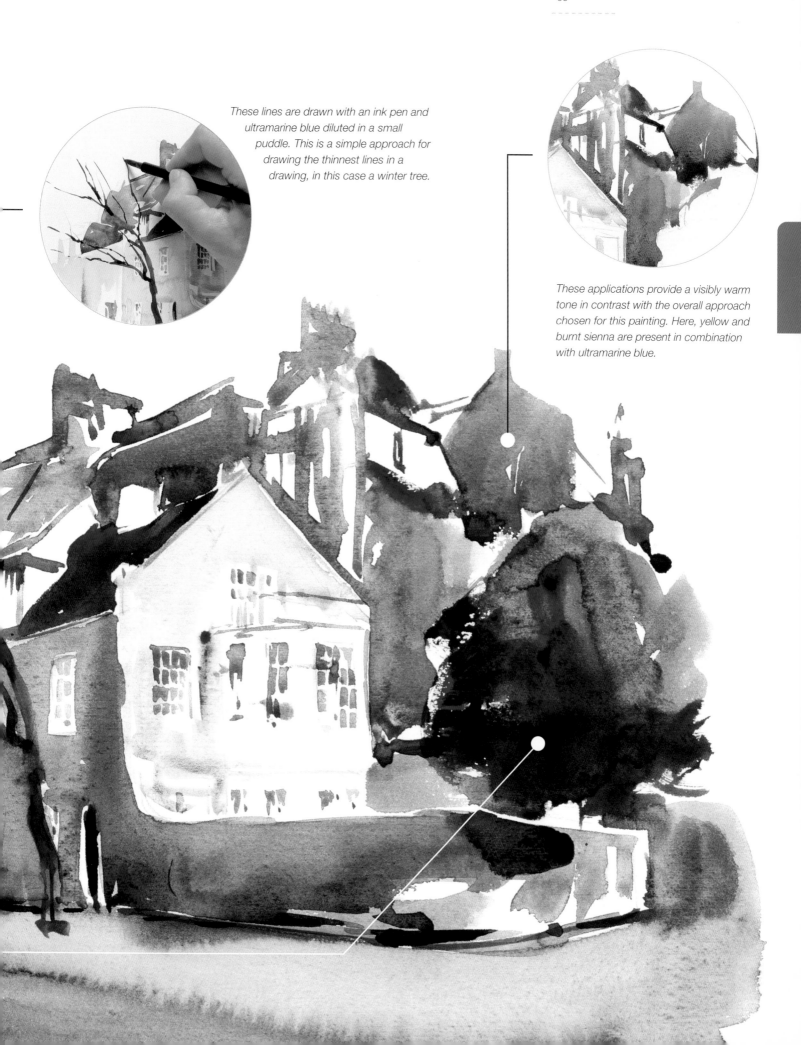

These lines are drawn with an ink pen and ultramarine blue diluted in a small puddle. This is a simple approach for drawing the thinnest lines in a drawing, in this case a winter tree.

These applications provide a visibly warm tone in contrast with the overall approach chosen for this painting. Here, yellow and burnt sienna are present in combination with ultramarine blue.

neutral colors are those that result from mixing complementary colors (blues with yellows, greens with reds). In theory the result is a neutral gray, but by varying the proportions we obtain muddy tones with a gray tendency, which are the ones that we find most frequently in real life and also in the work of most watercolor artists. In fact, nature does not usually display pure tones, rather all colors have a tentative feeling, an approximation. Putting this fact aside, any watercolorist who wants to emphasize and promote pure and vibrant tones, either warm or cool, must resort to neutral colors to create contrast and a visual "repose."

Chromatic Harmony
with neutral tones

NEUTRAL COLOR PALETTE

There is never a direct relationship between real-life colors and those from the artist's palette. The painter creates his or her own parallel harmonies to those suggested by nature, but they cannot be reproduced exactly. For that reason, the paintings of different artists present different color characteristics that speak of the subject and of the temperament and sensibility of the artist. A sensibility that many artists make use of is that of "muddy" tones, also called neutrals. A painter with a realist approach favors a neutral palette range, a range that we have called "muddy," but that does not necessarily have to be so: grays, browns, earth tones, and greens are among the most common colors within the neutral family, but they can also have a tonal purity of their own and incredible beauty.

These roofs are very dark gray with a purplish undertone. The violets and reds (iron oxide red) that are included here provide colors with warm and cool undertones, depending on how diluted the color is.

Even the foreground here, so markedly warm, has also been painted with a neutral color, the result of mixing burnt umber and some English red. The latter makes the color opaque in many areas.

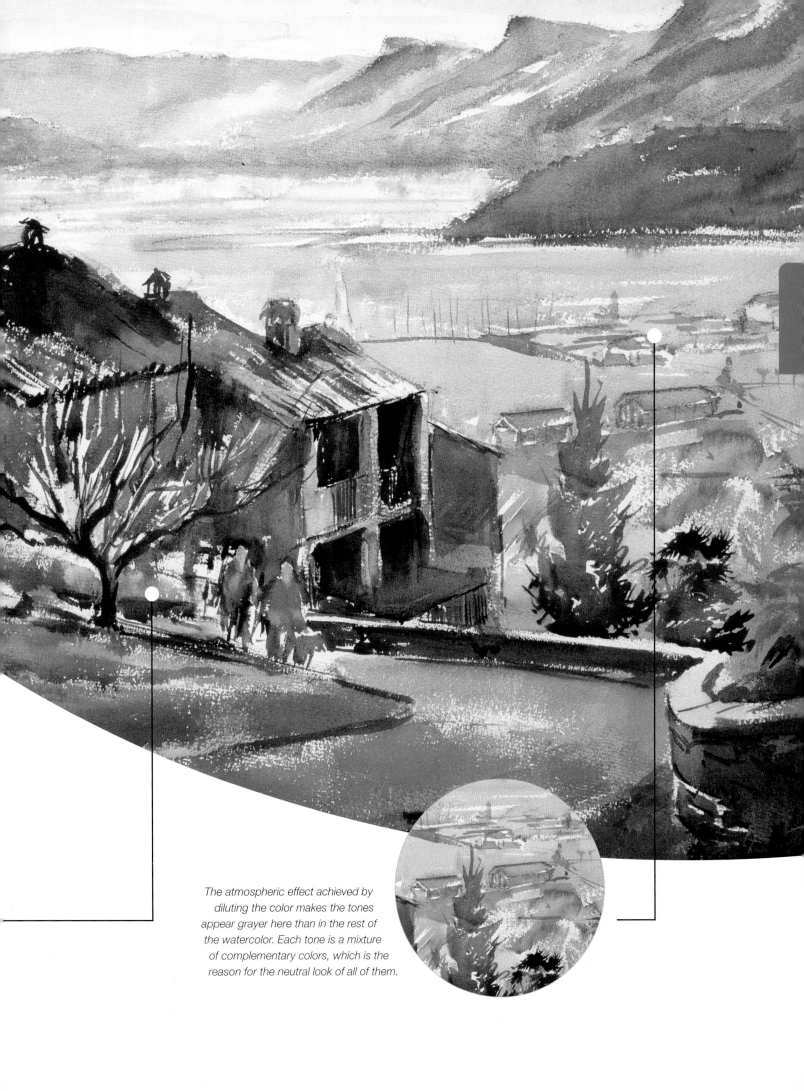

The atmospheric effect achieved by diluting the color makes the tones appear grayer here than in the rest of the watercolor. Each tone is a mixture of complementary colors, which is the reason for the neutral look of all of them.

Watercolor

Out-doors

"THE TRUE ARTIST MUST GET CLOSE TO THE GREAT BODIES (THE SKY, THE OCEAN, THE MOUNTAINS, THE PLAINS), AND TO EVERYTHING THAT RELATES TO THEM, TO SEEK AUTHENTICITY."
J. Marin.

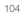

*P*lein air: Painting

from nature.

Plein air is a French expression
that means "outdoors."

The French Impressionists made this way of painting, which today seems so natural to us, popular. One hundred fifty years ago it was a novelty, something never seen before. A book on watercolors must necessarily cover this subject, because it is outdoors where the watercolorist finds himself or herself and enjoys the art. The following pages explore the work created on an outing to the coast on a changing spring day.

equipment
for *plein air* painting

to paint watercolor landscapes outdoors, the artist must have portable equipment with the following characteristics: complete, manageable, and sturdy. It must be complete in the sense that it should have the essential tools to work with but without omitting any of the accessories. To be manageable, it must be easy to carry around comfortably and not be cumbersome. It should be sturdy because when working outdoors, bumps and small accidents that can harm fragile materials are inevitable.

PORTABLE CASE

It is natural to think of a box, a case, or a bag to carry the paints, brushes, palette, sponge, blotting paper, bottles with liquid, and other required items.

To fulfill this need, major manufacturers of paint, brushes, easels, and other implements also supply fancy wood cases that include all the basic materials; however, while expensive, they do not completely solve the problem.

The solution can be a box made for oil painting that is adapted for watercolors. However, due to its size, it will not have enough room for a large container for water. Some professional watercolorists make their own wood cases to hold everything they need, including a plastic water bottle and the indispensable wide cup for the water.

EASEL

Portable easels used by oil painters can be used for watercolor painting as well. The most practical and solid of all the models is the easel-box, which includes the case for the brushes, the paints, sponges, pencils, and any other additional tools that are not very large. The top part can be tilted as needed and, once folded, it can be carried comfortably. Other painters prefer a simpler easel: a tripod with a support for the board that is simple and manageable, which, when folded, will fit into a large case for materials.

PORTABLE CHAIR

Watercolorists who do not like to paint standing up can carry a folding chair. There are small models, which when folded can be carried like a cane, and they are relatively comfortable. Most artists use small scissor-like chairs without a back, which are very light and more comfortable.

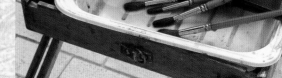

A box does not have room for large cans, but a plastic tray similar to a water pan does.

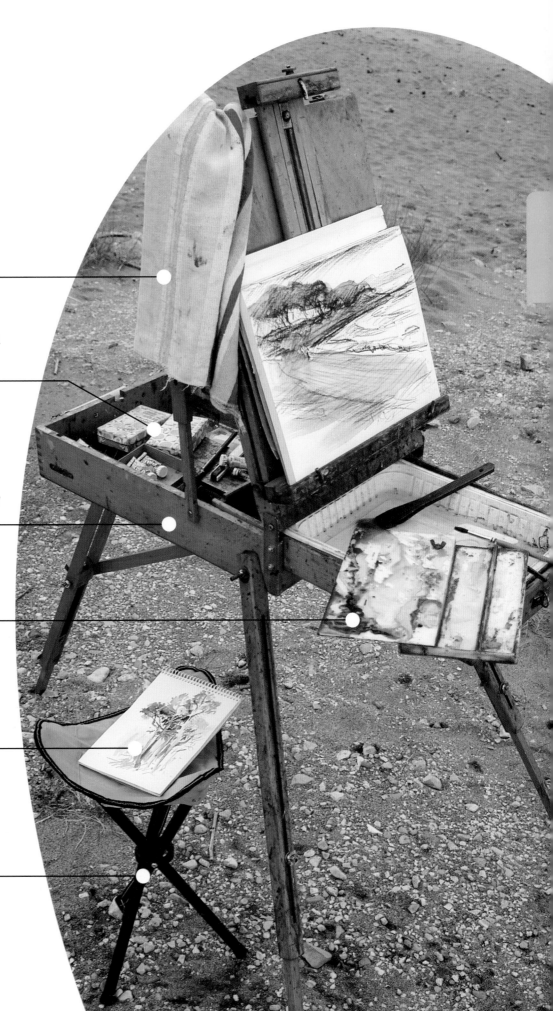

A towel or blotting paper is indispensable for drying the brushes and controlling the amount of water that is absorbed.

The easel has room inside for storing small materials (paints, brushes, rags, pencils, etc). With the easel unfolded, these materials are easily accessible.

Outdoor folding easel. Closed, it takes up the space of a small suitcase, and unfolded, it provides space and support for the indispensable materials for working outdoors. It is quite solid, and the height and angle of its upper tray can be regulated.

No matter what size palette the painter normally uses (except for the very large, studio ones), it can be stored inside the easel along with the rest of the material.

The sketchbooks and conventional watercolor paper pads are vital tools that can be carried inside a folder.

A folding chair like this one is comfortable enough for working without the artist having to carry heavy or bulky items that take up a lot of room.

Sketches and notes
from nature

It is not uncommon when we venture outdoors to make sketches, studies, and small color notes on sketchbooks or small pads (even pocket size), for future reference in the studio or to become familiar with the subjects before us. The studies are usually small and quickly made and may not look like they are finished, but they are complete. The sketch includes what is required, that which is needed, just enough.

THE USES OF A SKETCH

For the artist whose main interest is light and atmospheric quality, the essential idea of a landscape can be expressed in very few strokes that will suggest the quality of the light. For those who look for the solidity of the volume, the sketch will consist of the indications of several rock areas or a group of tree trunks. In either case, the sketch or study should be quick and expeditious; there is no room for corrections or embellishments. If it does not turn out well, another sketch is made. Many artists make these small works of art to sharpen their sensibility, to concentrate and begin working: to get warmed up. Sketches can also be useful for trying out techniques; to test papers, brushes, or any other new tool; or to look for "shortcuts," for synthesis in the representation of a landscape. The speed of a sketch, its quick and immediate quality often achieves what a conscientious approach cannot.

Small tabletop easel that is very useful on outings as a tool for making sketches. It has an adjustable support and enough space in its case to store the material needed.

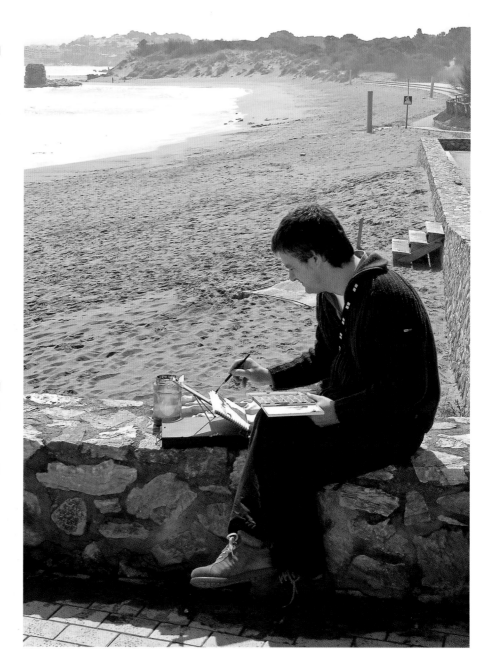

TOOLS FOR SKETCHING

Even though the tools required for sketching will fit in a pocket, on these pages we show some specific tools, like a small metal easel the size of a large book, which also has room for paints inside. There are also miniature boxes for making small color sketches, but they are not practical. The best approach is to use a conventional palette, most of which are portable. A single brush is usually sufficient in these cases.

The best time to work outdoors is when there is no wind and the sky is a little overcast, so the intense light does not wash out the colors.

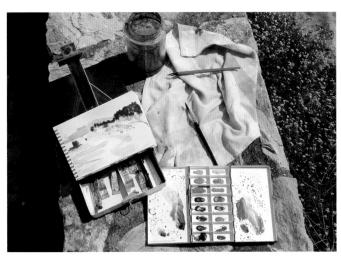

Very few tools are needed for sketching. A complete set is shown in this picture, including a paint box, a case (which is also a small easel), the indispensable rag, a brush, an ink pen, and the water. All of this is light and easy to carry.

The case of this small easel has enough space to hold the color tubes or cakes, brushes, pencils, and other drawing materials. If needed, you can also store a miniature box of paints and even a small sketchbook in it.

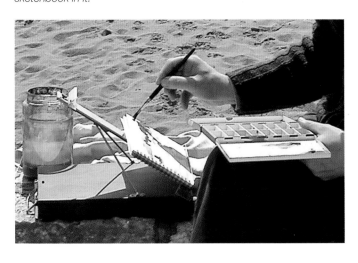

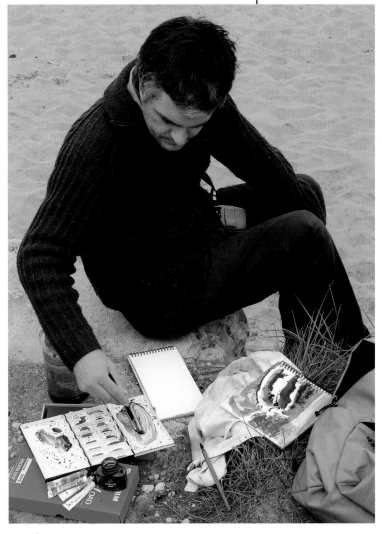

This box of paints is the conventional type, much more practical and comfortable than the miniature boxes and not much larger than the latter when folded. Its only inconvenience is that it is made of enameled metal, which makes it a little heavy; on the other hand, it is very strong and sturdy.

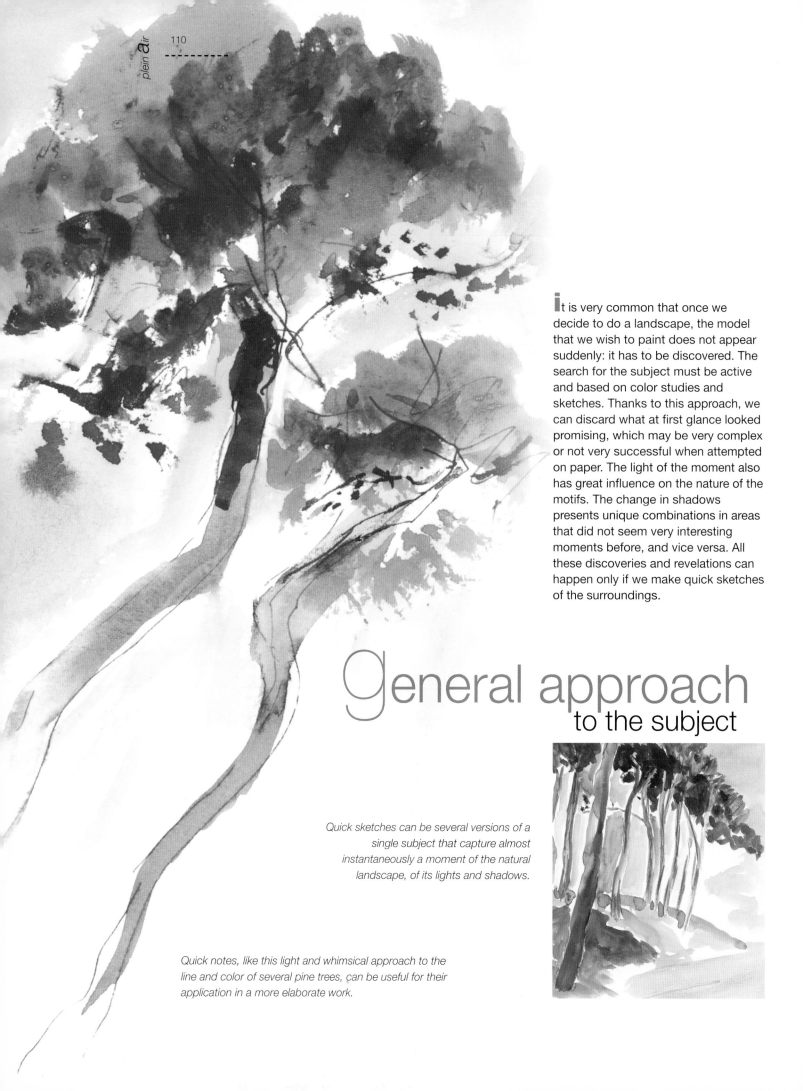

It is very common that once we decide to do a landscape, the model that we wish to paint does not appear suddenly: it has to be discovered. The search for the subject must be active and based on color studies and sketches. Thanks to this approach, we can discard what at first glance looked promising, which may be very complex or not very successful when attempted on paper. The light of the moment also has great influence on the nature of the motifs. The change in shadows presents unique combinations in areas that did not seem very interesting moments before, and vice versa. All these discoveries and revelations can happen only if we make quick sketches of the surroundings.

general approach
to the subject

Quick sketches can be several versions of a single subject that capture almost instantaneously a moment of the natural landscape, of its lights and shadows.

Quick notes, like this light and whimsical approach to the line and color of several pine trees, can be useful for their application in a more elaborate work.

An exploratory sketch can be nothing more than a few brushstrokes divided into different masses of color completed with a few directional lines. It may be no more than a simple shorthand painting that tackles a composition as its maximum synthesis without a specific aesthetic goal.

The goal of this watercolor (which appears in progress on the easel in the previous photograph) was to be a simple sketch, as seen from the loose and liberal (even the pencil lines) strokes that are visible in some of its sections. The possibilities presented by the subject encouraged the artist to finish it more elaborately.

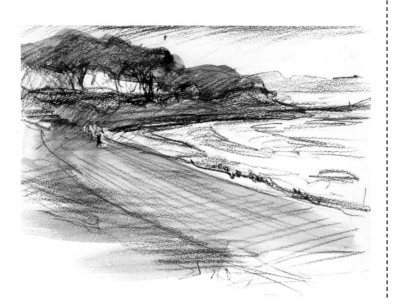

MASSES, LINES, AND CONTRASTS

A landscape can be approached in many ways. We can, for example, interpret it from the point of view of large areas of light and shadow (the foliage against the sky, the rocks against the sea, etc.), or else pay attention to its linear configuration (the tree branches, the outline of the horizon, etc.). It is very important to make these distinctions, since a sketch cannot embody all the richness of a subject. We must choose, even eliminate almost everything that is visible except a few relevant details that will later help us create the final work.

These lines, purely resembling a drawing, try out a linear solution for a group of trees whose branches suggest rhythmic movement finished off with their treetops, which are also resolved as if it were a line drawing.

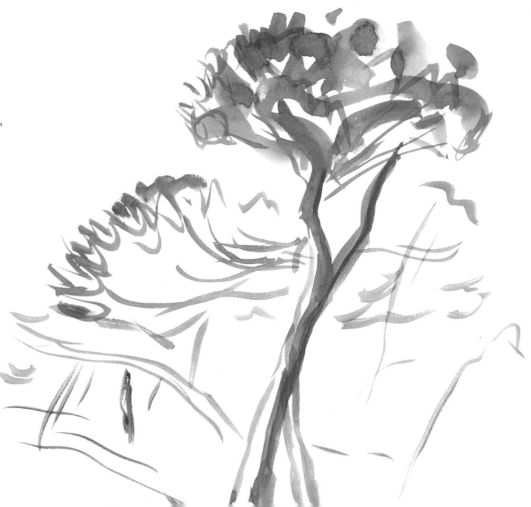

Compositional
study

each time the painter goes outdoors to work and faces a landscape, it calls for a new spirit, for a different arrangement of the technical elements, a new synthesis of the resources. This is not only because the sky, the light, or the shapes of the landscape may have changed, but because the experience acquired with the previous works places the painter at a new starting point.

There is nothing better when tackling a new subject than to make sketches without worrying about the approach or the style. These sketches allow the artist to overcome the fear of making mistakes and also help him or her to discover new unforeseen solutions.

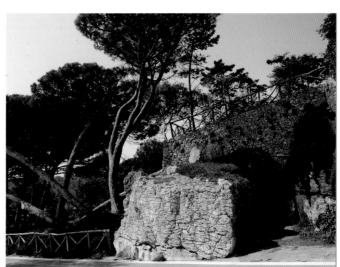

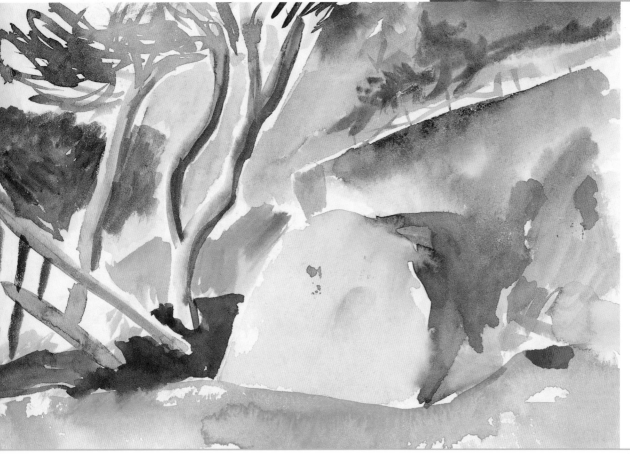

This and the other sketches on this page deal with the same subject seen from different perspectives. They are composition studies that search out the most favorable angle for executing the work. This is a frontal view of the subject, similar to the one chosen in the end.

A TENTATIVE APPROACH

Sometimes, the artist resolves the work with one sketch: he or she tries to make it very concrete and to know precisely what he or she wants. However, most times the study is centered on a particular element: the composition, the format, or the placement of the subject; perhaps some particular forms, or the illumination, the color range, and so forth. When it comes to composition in watercolor, taking notes is especially useful. A few areas of color suggested by the landscape can provide a composition that inspires the final work, without the need for the represented forms to be exactly like the real ones. Besides, a sketch made of a specific landscape may someday serve as the inspiration for the composition of a different landscape, or a fragment of it.

In principle, a sketch is not intended to be a work of art, but rather a practice exercise. Some of them, however, may turn out to be very attractive.

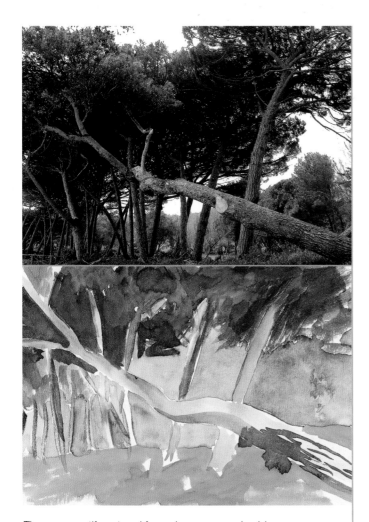

The same motif captured from closer up, emphasizing the direction of the tree trunks. This is an interesting aspect although somewhat devoid of air and of atmosphere.

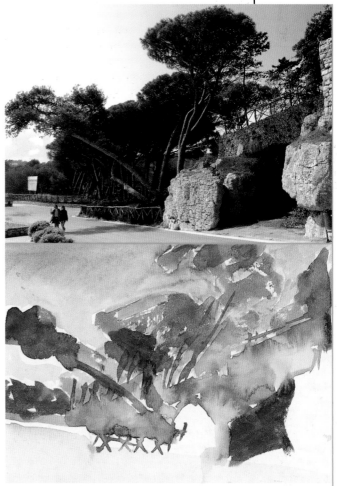

A panoramic view where the landscape is shown somewhat in perspective. The sketch was created with a few very loose strokes that are an initial spatial approach to the motif.

Interpreting a real Subject:
pine trees on the coast

after a short walk and drawing a few sketches here and there, and after considering the wind and finding a protected area, we set up the easel facing the sun in such way that the shadow of our hand would fall to the right and not be an obstacle when painting. If the sun were very bright the selected location would be in the shade because the white of the paper is a blinding surface in bright sunlight. We take a medium-size paper about 16 x 24 inches (40 x 60 cm) and attach it to the portfolio with a few clips. Then we begin to paint. The session lasts a little over an hour. On this page you can see the chosen subject and the result of the work. Comparing both will help us arrive at some interesting conclusions.

One of the interesting aspects of this group of pine trees is the trunks that cross the composition from side to side: this is an excellent feature that gives the work a dynamic look and a strong visual effect. The great amount of details and intricacies of this theme must be synthesized, an approach that is visible in the details illustrated on these pages, as well as the processes presented on the following ones.

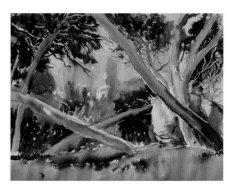

Painting this watercolor has taken a little over an hour. The rhythm was very fluid and the changing aspects of the motif were condensed, a summary in which the outstanding feature is the simplicity of the approach to the intricate details of the scene.

The drawing was made with a blue pastel pencil. The lines were blended and sometimes mixed with the watercolors to integrate them into the composition.

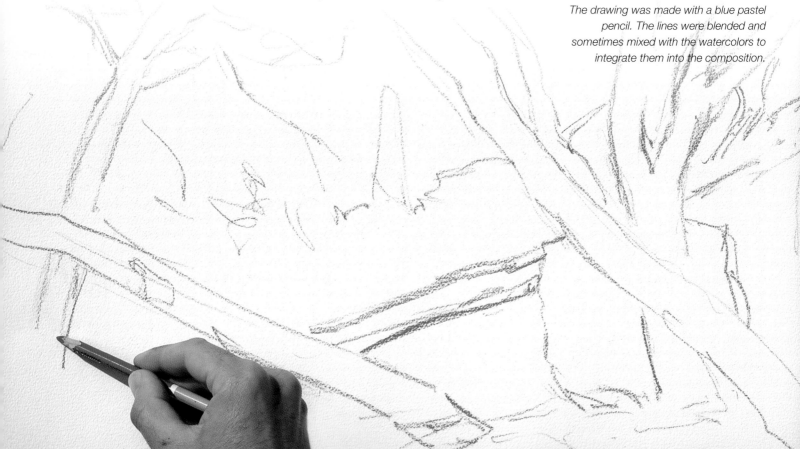

No matter what the subject is, the mixtures on the palette must be generous in the amount of color and water used.

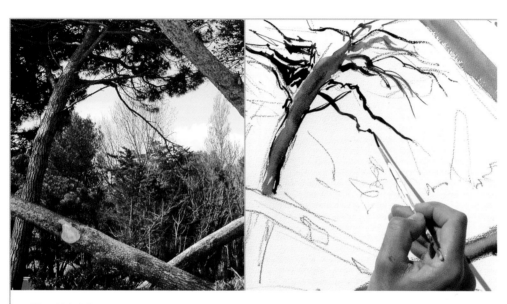

The thick foliage of the treetops presents a dense texture made up of the needle-like leaves complicated by the intertwining of the branches. The solution has been to cover this area with loose brushstrokes of blue-gray, a color that is repeated on all the shadows of the top area of the painting. The linear texture of the foliage was resolved at the beginning of the work with a very thin round brush.

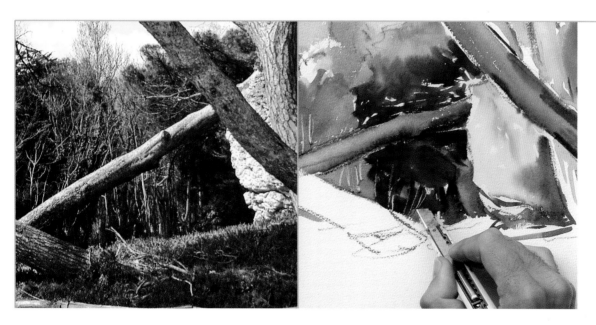

To create the illusion of the tall grass in the middle plane, we have used a blade to scratch the paint while still wet. The foreground was created with generous green washes applied wet on wet. All the minute details of the leaves have been ignored to create a large mass of color that compensates and contrasts with the abundant details of the upper part.

Sketches of the ocean
and the Beach

the sea is a truly difficult subject for a landscape artist. We refer to the sea by itself, to the endless body of water with no references or features that alter its appearance. Even then, it is worthwhile making sketches and color notes of the sea to evaluate its (few or little) artistic possibilities. The examples presented in these pages were taken in front of the beach while searching for an appropriate subject for a large watercolor.

The tests recreate the waves by the rocks with greater or lesser definition of the coastline. The final selection included a composition with a large sand jetty in it to provide boundaries and to define a theme that is as suggestive as it is limitless. These sketches provided the study of a beach scene whose development is explained in the following pages.

From these rocks we can view a large body of sea and coastline. The studies illustrated on these pages have been captured from here, and the work done in the small sketchbooks that are shown in the picture. The wind, which curls the surface of the water and creates masses of foamy water near the rocks, makes the large body of water that we have in front of us much more interesting.

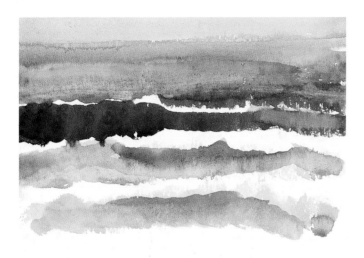

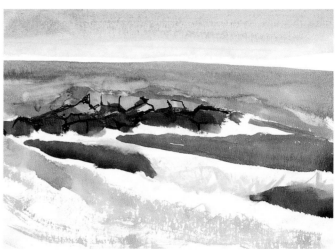

The sea, with no other reference than the waves, can only be represented spatially through their size and vastness. The different color bands of water form a very simple, but at the same time suggestive, compositional design that can be resolved with just a few brushstrokes of color combined in different ways.

The presence of rocks or of a jetty creates an incredibly useful reference when defining the surface of the ocean, as well as the distance between the foreground and the horizon.

Representing the sea does not require complicated techniques. The normal approach is to create wash studies using a single color applied with quick brushstrokes, completing them with a few areas of color of different intensities. The painting is resolved by working on the overall form, the light, and the shadows, all at the same time.

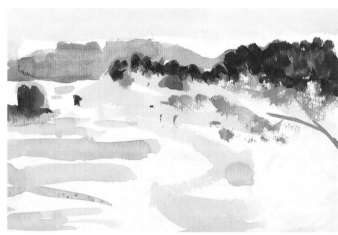

The spatial challenges can have multiple solutions if we move the point of view toward the coast, because the sandy beach, the rocks, and the bushes create reference zones that help indicate the various planes.

A looming storm increases the interest of the seascape: the waves become rough and break against the rocks of the coastline, creating an extraordinarily appealing composition for the painter.

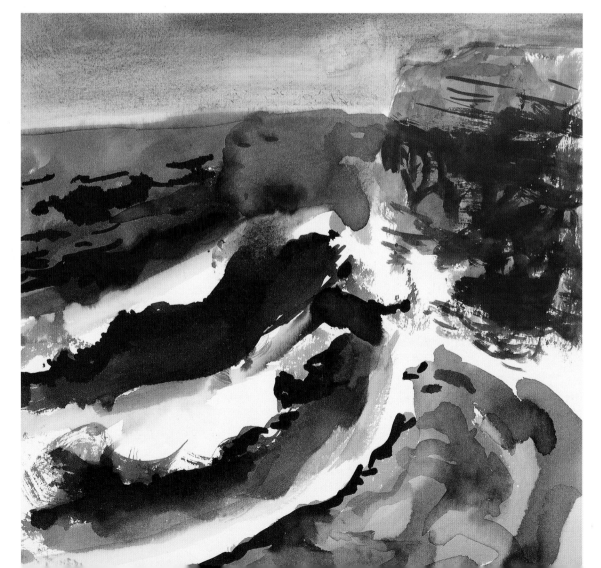

after a series of studies of the sea, a decision was made and a view of the beach with a generous strip of sand in the foreground, several pine trees in the middle ground, and the sea located to one side of the composition has been chosen. It consists of a very "empty" subject matter where the foreground occupies most of the composition. This means that the painting will be short on details and the interest will reside in the variations of intensity in the large areas of wash, and in the simple and plain color contrasts.

Interpretation
of the motif: the beach

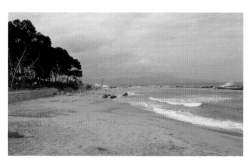

In the end, the simplest subject is chosen. On this gray day on a beach, a few figures can be seen timidly approaching the water's edge. During the process, some of them took a quick plunge in the water, something that is seen in the watercolor but not in the photograph.

THE SKY

The sky is an unavoidable subject in the *plein air* outings and one of the favorite themes of watercolorists in general. This is no surprise, since watercolors are the best medium for representing the sky, as if the method were in perfect harmony with nature. The same thing happens with the sea: the watercolor wash is the approach that has the greatest affinity with nature.

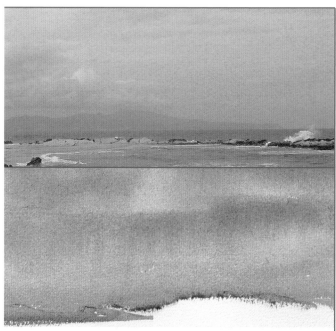

The sky has first been painted with a blue ultramarine wash over a previously dampened paper. The humidity in the environment has helped spread the color. The area of the trees has been reserved and the wash on the lower part, which is level with the horizon, has been finished with a blue band of phthalo blue, brighter than the watery ultramarine.

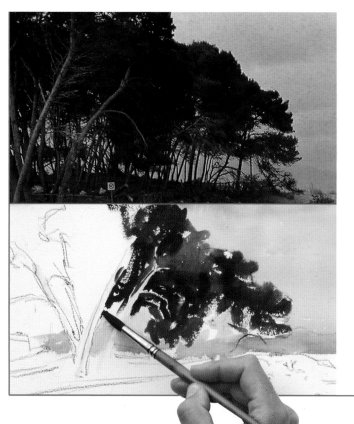

The treetops have been painted with very dark green-gray brushstrokes. No changes of color are introduced in these areas because we are looking for the contrasting effects of dark over light. The foliage is modeled with varied brushstrokes.

This affinity is confirmed by the watercolor shown in these pages. A sky with well-defined clouds and precise shapes requires layers of color on a dry support, transparencies for the shade, and many white reserves to make sure that they are as clean as possible. An overcast sky, such as this one, requires an application of wet on wet, with a lot of water, in which the brushstrokes lose their unity and blend with each other, working loosely and trusting that the dynamic of the wet paint will result in the most appropriate finish. The moisture outdoors will prevent the colors from drying too fast.

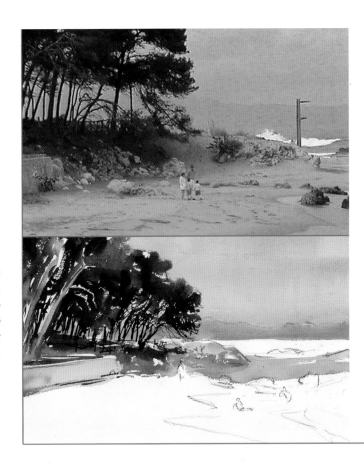

The area immediately below the treetops has been treated in detail and with diligence. Each tree trunk has been defined with the tip of the brush and alternating earth tones to express the shadows. Notice the lines of the drawing that were in this area of the composition.

This watercolor is the product of adaptation: adaptation of each of the few compositional elements that form its parts and adaptation also of the incorporation of those elements into a coherent unity. Washes and the sparse colors are the dominant factors.

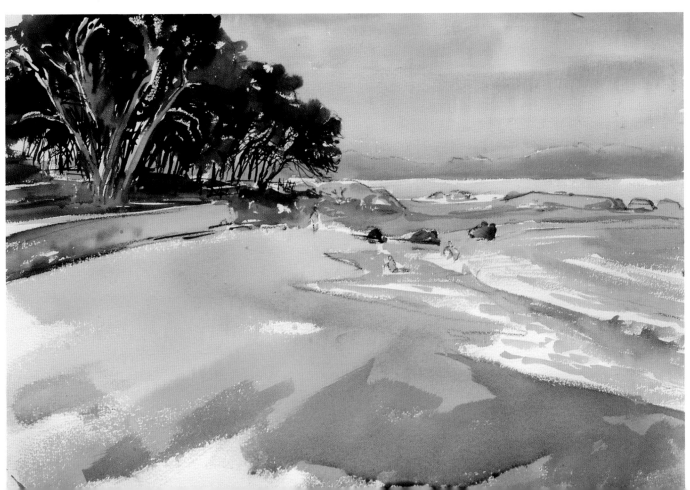

Step

"IT IS UNFORTUNATE FOR A PAINTER WHO HATES APPLES TO HAVE TO PAINT THEM
BECAUSE THEY LOOK GOOD IN THE COMPOSITION. I PUT THE THINGS THAT I LIKE IN MY PAINTINGS."
P. Picasso.

by Step

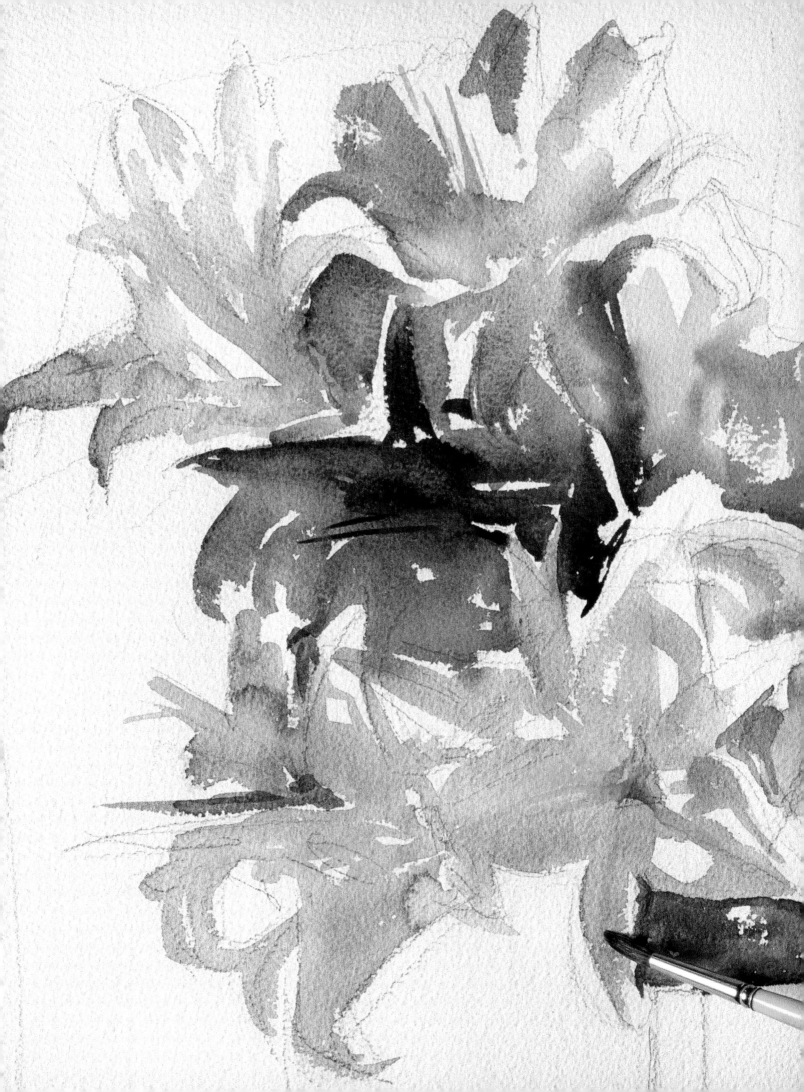

the Atmosphere
in a Landscape

this exercise has been developed with the sole purpose of demonstrating how to create an atmospheric effect. Therefore, its execution (undertaken by Vicenç Ballestar) is limited to creating that effect without further developing the representation of the subject. The colors are applied wet to reduce their saturation: these are colors whose contrast is affected more by their tint rather than their tone, which appear like delicate airy layers that leave space for the humidity in the air. The landscape is more evocative than realistic.

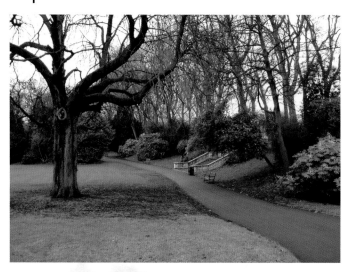

1

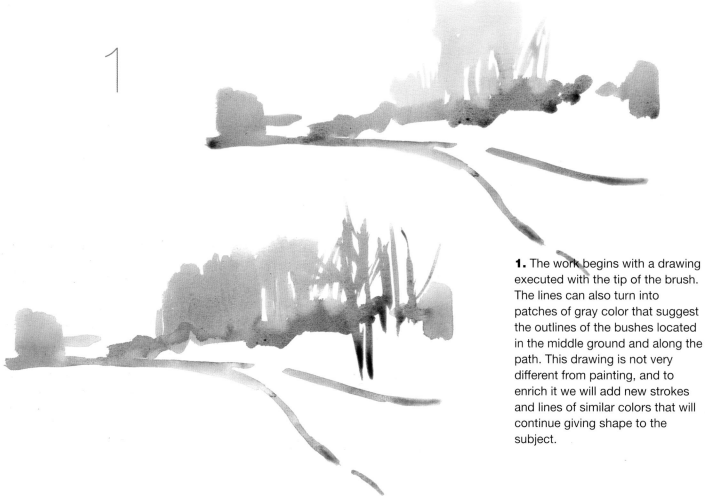

1. The work begins with a drawing executed with the tip of the brush. The lines can also turn into patches of gray color that suggest the outlines of the bushes located in the middle ground and along the path. This drawing is not very different from painting, and to enrich it we will add new strokes and lines of similar colors that will continue giving shape to the subject.

Light grays and greens are the colors that best reflect the moisture in the landscape's atmosphere. The grays can be created by mixing earth tones and blues diluted with water; this mixture provides a very rich gray, quite suitable for use in different intensities and for painting the backgrounds. The cold greens, mixed with a small amount of blue, also convey this feeling.

2

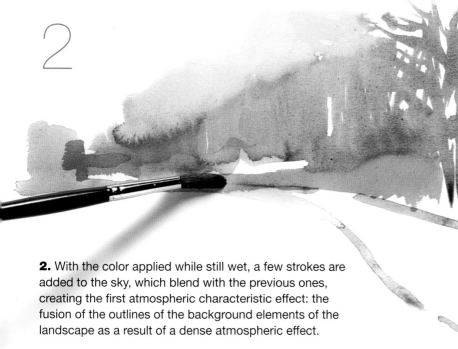

2. With the color applied while still wet, a few strokes are added to the sky, which blend with the previous ones, creating the first atmospheric characteristic effect: the fusion of the outlines of the background elements of the landscape as a result of a dense atmospheric effect.

3

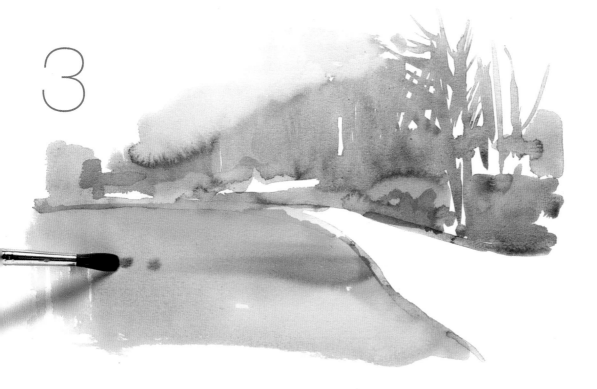

3. The grassy area in the foreground should not be completely flat, but rather modeled by the different concentrations of paint in the water. Therefore, the most saturated areas suggest features of the terrain and express their extension and their undulation. The entire area of color is a single and smooth surface with no brush marks.

4

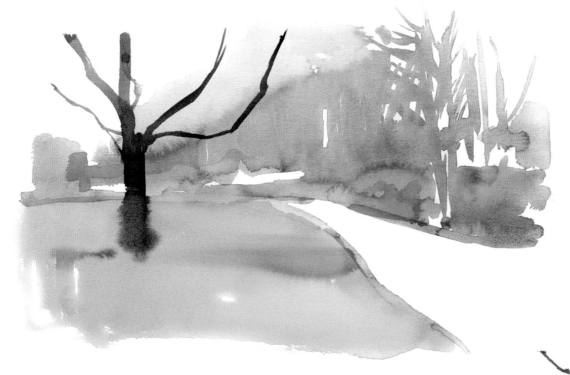

4. The tree was created entirely from a single brushstroke of burnt sienna mixed with a small amount of ultramarine blue. Care was taken to charge the brush with more water in the upper part of the branches so they would blend a little bit with the paper where they appear cut off at the top.

THE ARTIST COMMENTS

The delicate look of this watercolor is due to a very calculated use of color and to an extreme sobriety in the use of the palette. The soft green tones of the foreground form part of a single block of color, allowing the action of the diluted color to define the shading (A). The tree branches do not follow a systematic or routine arrangement, instead they are drawn in a specific and convincing manner (B). The atmospheric effect can especially be appreciated in the background where the faint colors blur the solid forms of the landscape (C).

A

B

C

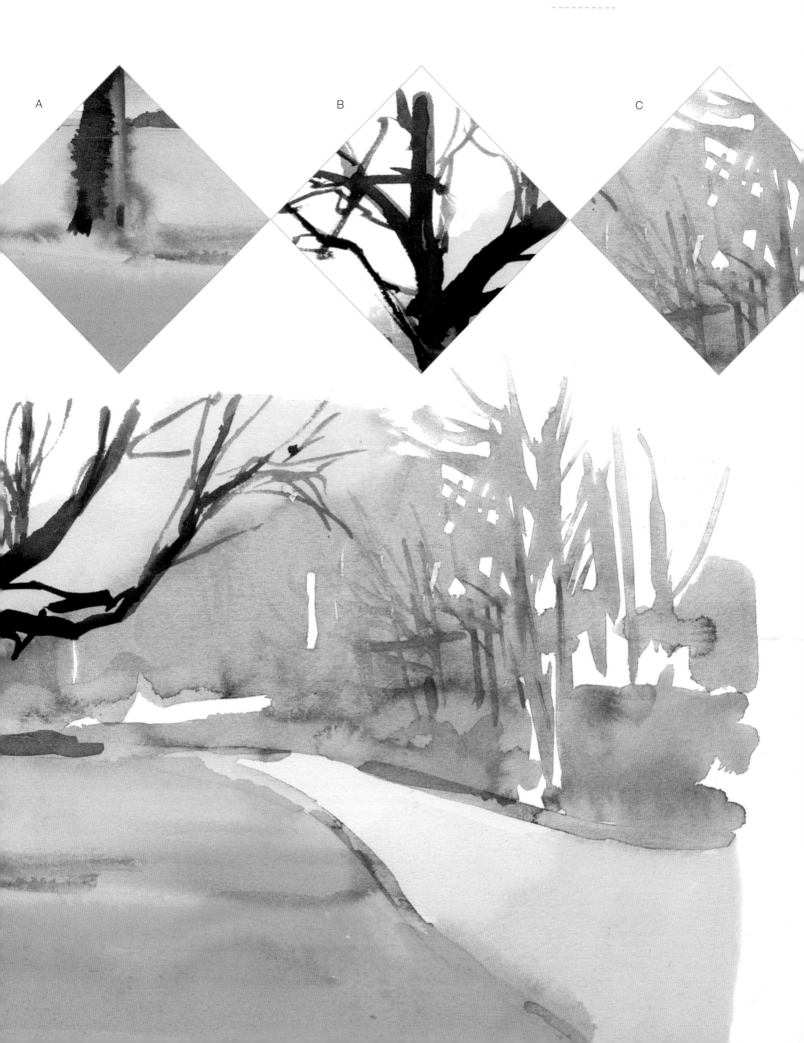

The sky: the volume
of clouds

Sometimes clouds have a much more imposing volume than any other solid object in the landscape. By themselves they can have a strong enough presence to justify an entire landscape. Here the painter (Vicenç Ballestar) has chosen the motif just for the attractiveness of the clouds, and completes it with brief indications of the terrain. These indications are very important for conveying a sense of the scale, to emphasize the monumental character of the cloudy spectacle and also to highlight its volume.

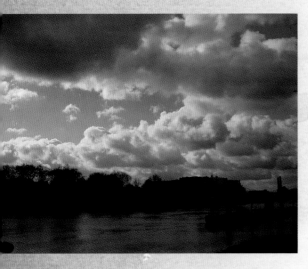

1

1. The blue sky defines the bright white of the clouds and acts as the background; the gray shadows of the clouds in the sky have, in some areas, a lighter tone than the blue of the background. The values of those grays must be compared constantly to make sure that at the end the clouds look realistic. Flat and round brushes are alternated to model the gray shadows.

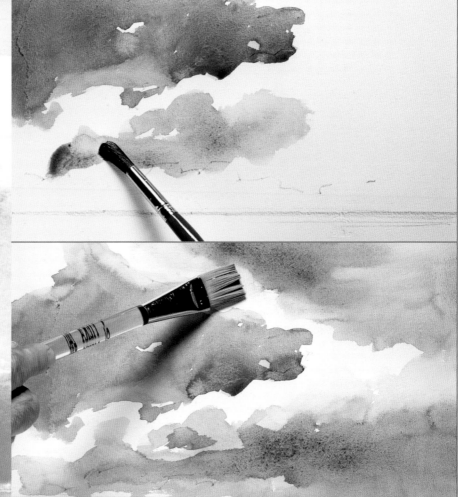

Like all objects located in a deep space, the clouds vary in size according to the distance. Determining that distance for the sky is more difficult than for the ground due to the lack of reference points. Figuring out the distance of the clouds is an intuitive task that the artist must undertake quickly because the shapes of the clouds change constantly and there is hardly any time to sketch them on the paper.

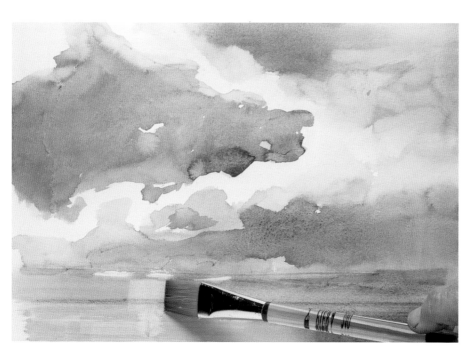

2

3

2. A sky with well-defined clouds that have some volume requires the dry on dry painting approach with layers of color and many white reserves to make those whites as clean as possible. A gray and overcast sky requires an approach in which the brushstrokes are built up and where the artist works without fearing that the color will dry too fast and will ruin the overall effect. This case is in between: white reserves and grays with abundant water.

3. The trees that cover the horizon finally provide some scale for the clouds, as well as for their distance in the sky. These areas of color are created with Payne's gray dissolved with a small amount of water to form a unique silhouette. The surface of the river has also been painted with the same gray mixed with a very small amount of carmine.

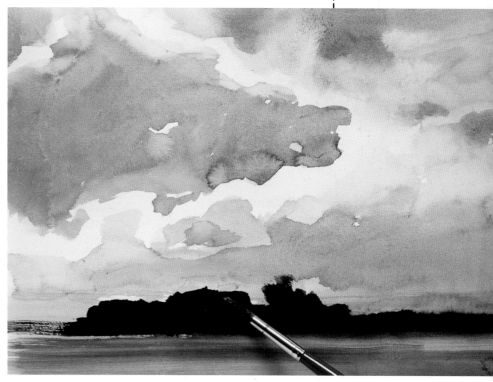

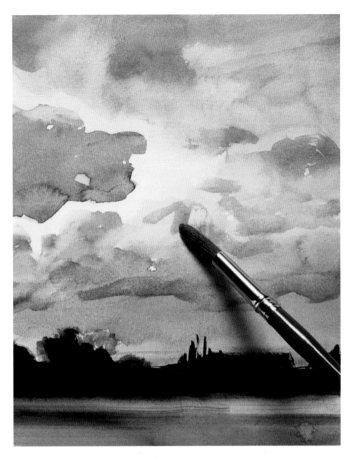

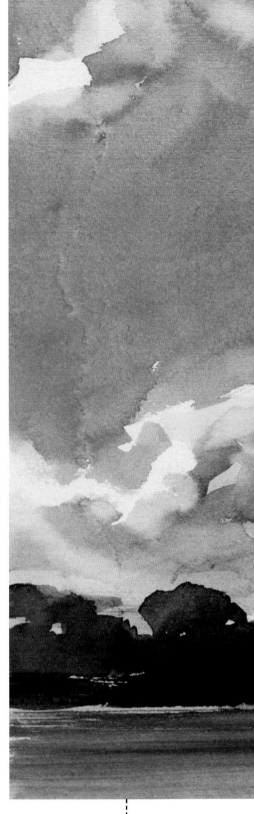

4

4. All that is left to do is to define the most distant clouds. By adding more shadows and more combinations of gray we have created the feeling that at that point the clouds are smaller, therefore this area of the composition would be farther away.

THE ARTIST COMMENTS

Very few colors are needed to represent a cloudy sky. The crucial part is to pinpoint exactly the right combination of reserves and the modeling of grays. The blue sky is a barely defined ultramarine blue (A). The blocks of gray color are larger or smaller depending on their distance from the observer (the closer the clouds, the larger the area) (B). The horizon with its tree line indicates the scale of the representation (C).

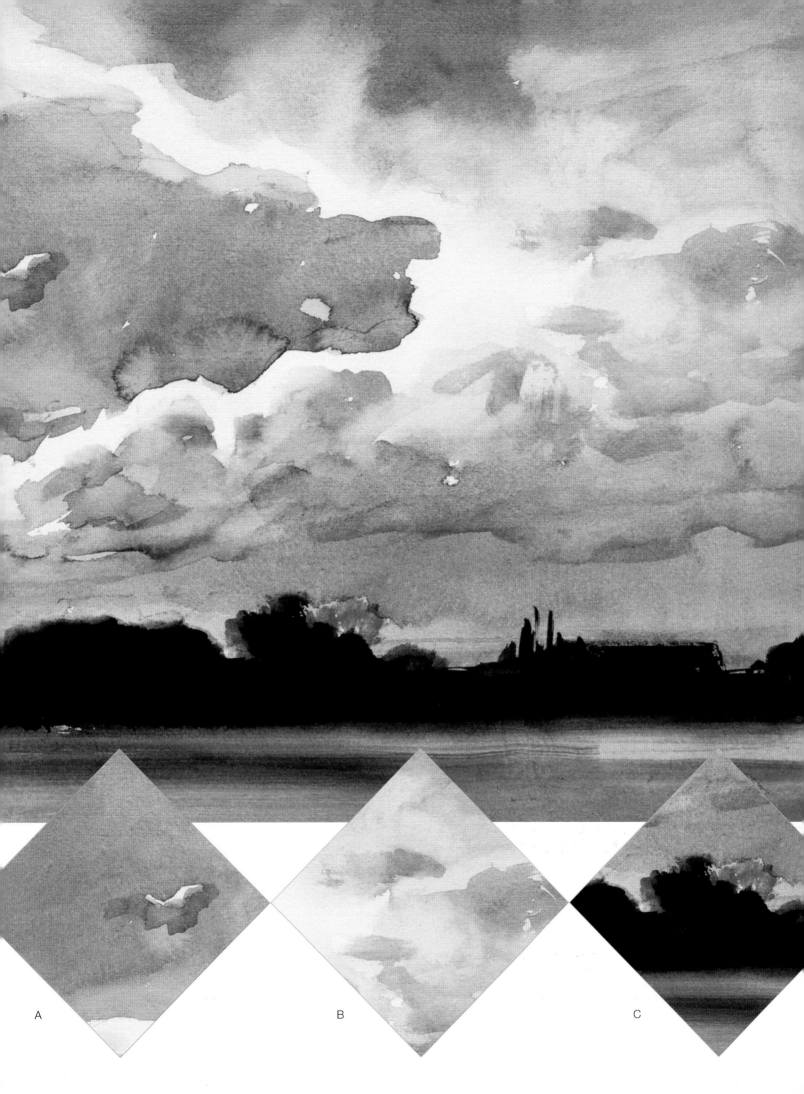

A

B

C

A Quaint Corner
in a Small Village

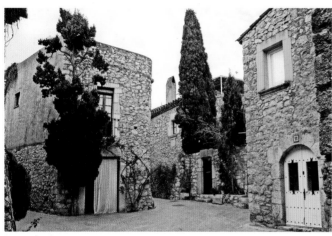

this theme is an irresistible temptation for any watercolorist: a medieval corner in a small rural village. The volumes, the play of shapes, and the light and shadows seem to have been created especially for painting a watercolor. The artist, Óscar Sanchís, approaches and renders the subject with extreme simplicity, to the point of leaving the sky white, unpainted, to highlight the purity and freshness of the colors used in the rest of the watercolor.

1. The façades are painted first, reserving the shapes of the trees. Very diluted ultramarine blue and burnt sienna are used. Alternating blue and sienna on the façade to the left creates a beautiful color surface that was maintained almost unchanged until the end.

2. We continue to paint the façades using only very diluted sienna for the closest one. This warm tone helps strengthen the foreground, as do the colors that define the edge of the closest wall: an important contrast for the spatial representation of the scene.

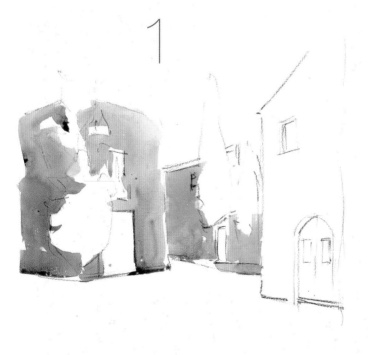

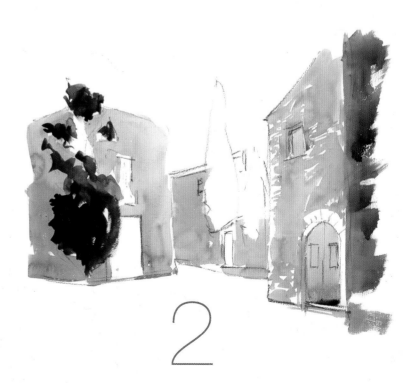

THE ARTIST COMMENTS

The watercolor is considered finished without ever touching the sky. In some instances, the white of the paper perfectly fulfills a representational role, much better than any color application would: the white is the overcast sky. The basic details, such as the small balcony (A), or the cypress tree that occupies the center of the composition (B), stand out as examples of artistic synthesis. The door on the right is also a subtle and simple color detail (C).

A winter landscape

no other medium is better for creating the most diverse weather effects with precision and sensitivity than watercolors, especially fog, rain, and snow: all the phenomena relating to atmospheric density, heavy clouds, transparency, soft colors, and the like. Here Mercedes Gaspar creates a snow scene in which the atmospheric quality and the delicate nuances do not conflict with the energetic contrast of the shades of color.

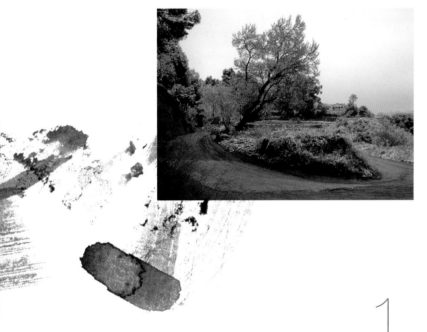

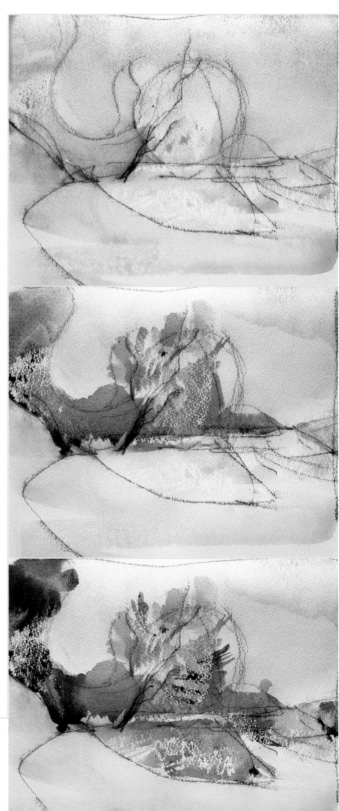

1

1. An extremely loose charcoal pencil drawing begins the process of this work. The sketch is fluid and natural, and it sets up all the areas of the landscape with a clever linear arabesque. The artist has previously reserved several areas of the paper with white wax; the color, therefore, affects only the areas that are not covered with wax: a very light pink for the sky and a dark gray for the most distant points of the landscape.

White wax is the easiest medium for making reserves on paper when the reserves are so small that making them with a brush would be very complicated. As can be seen in the different phases of this exercise, the wax lines are clearly visible and evoke snow on the fields and on the trees.

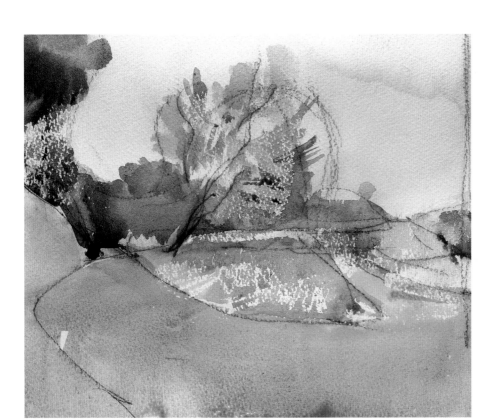

2

3

2. This large central area of burnt sienna establishes the basic elements of the watercolor's color scheme. This warm foreground vividly contrasts with the cold feeling of the rest of the watercolor and conveys the illusion of depth. In other areas the gray tones have been diversified with the addition of several neutral blues and grays.

3. Although it is not common, using a pencil in the middle areas of the work is perfectly acceptable. In this case, it allows small contrasts to be redefined and areas to be detailed without altering the overall color: the farmhouse that appears in the background is one of those details that can be resolved in this manner.

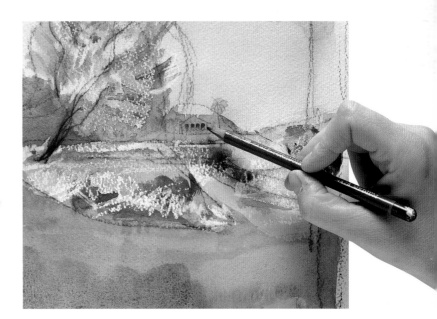

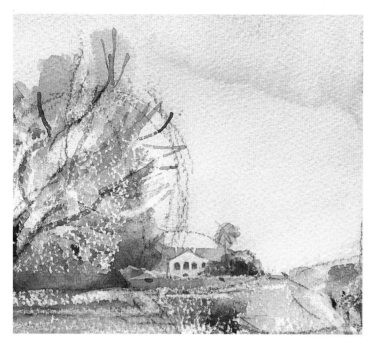

4. The clear contrast between the areas that have been colored, with no details other than the water in the painting, and the areas that are full of details, or better said, that have been drawn, adds vitality and artistic strength to the work. The delicate nuances and the light tones of the colors are thus emphasized.

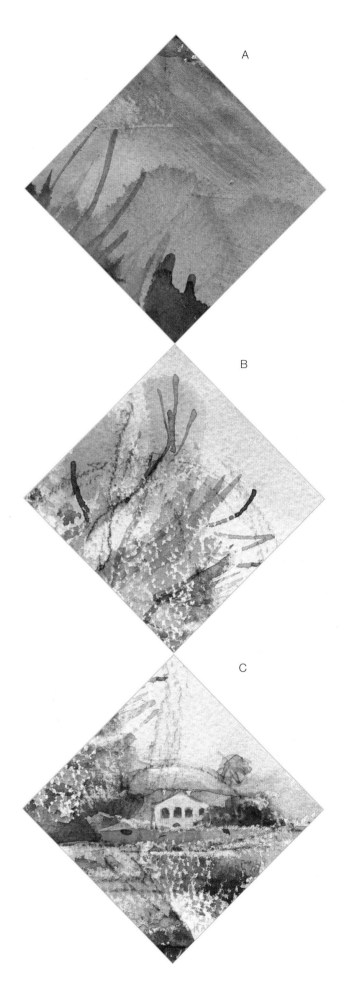

A

B

C

THE ARTIST COMMENTS

The approach to the foreground is the simplest possible: a large area of burnt sienna (great amounts of water and paint) quickly spread, allowing the action of the diluted color itself to contribute the nuances here and there, creating more saturated and more transparent areas (A). The complicated combination of dry leaves, snow, and dense atmosphere of the background, around the central tree, has been effectively resolved with a series of wax reserves (B). This house located in the background of the composition has been worked much more than any other detail of the foreground; this contrast reinforces the special effect of the simple color contrast (C). The grain of the paper provides the characteristic texture of the work, highlighted by the wax applications.

D

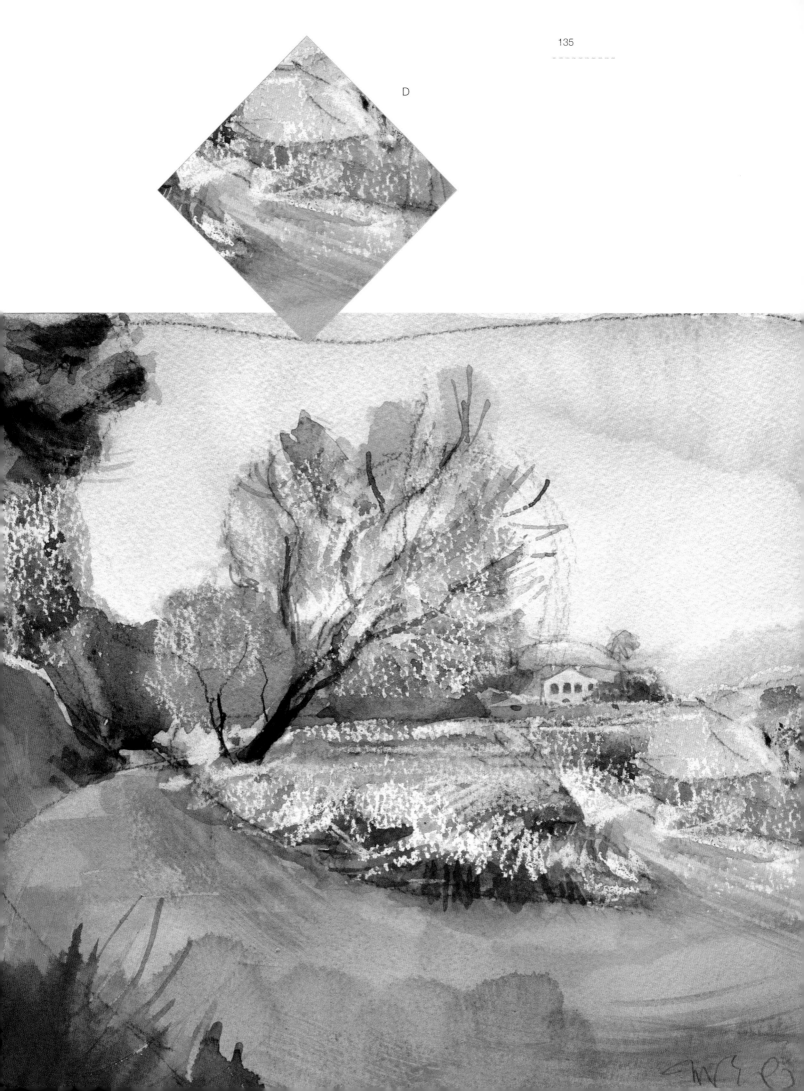

An Urban landscape
in Bright Sunlight

this watercolor depicts a large panoramic view of a village from an unusual perspective: a great plaza surrounded by a large balustrade. This architectural feature introduces an interesting compositional variation that organizes the space in a dynamic perspective, while creating a powerful chiaroscuro effect. It will therefore be a watercolor based on strong contrasts and sudden changes of scale, reinforced by vibrant colors. It is painted by Óscar Sanchís.

1

1. The initial drawing is precise and detailed. It contains almost all of the architectural outlines of the panorama. However, the execution is very simple and schematic, avoiding deep lines. Painting begins with an extremely diluted wash for the sky and continues with the earth-green tones of the trees in the background, which are created with small brushstrokes of diluted color.

Normally the foreground of a landscape must be emphasized with some energy. The intense color that goes in this area has been painted quickly, using a lot of paint so the brush covers a large surface by flowing across the paper effortlessly.

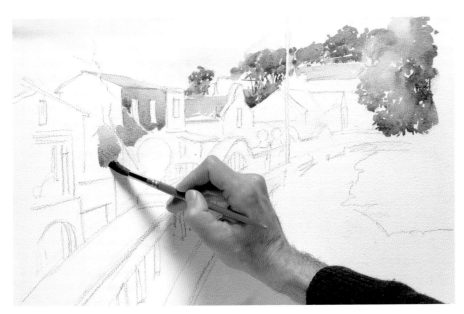

2

2. As the basic background for the work, violet tones have been used for the shadows and light pinks for the highlights: a strikingly luminous contrast. The roofs are covered with the pinks while the façades, which are facing west, are painted with the violet tones. The precision and the attention to the initial drawing make the orderly distribution of these areas of color easier.

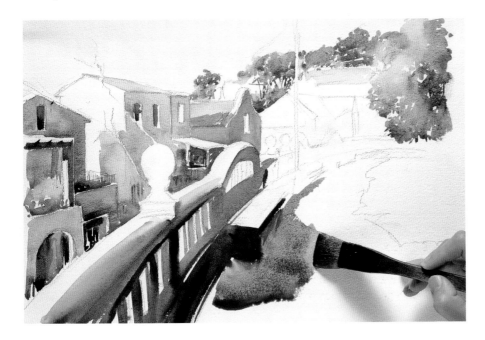

3

3. The shadows of the rail and the balusters are painted with a mixture of cadmium yellow and a small amount of quinacridone violet: the resulting color is a dark and somewhat muddy orange that blends with the purest yellow of the upper part. A pure violet cast shadow is painted liberally on the foreground with a flat brush.

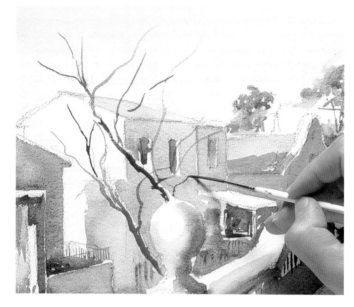

A

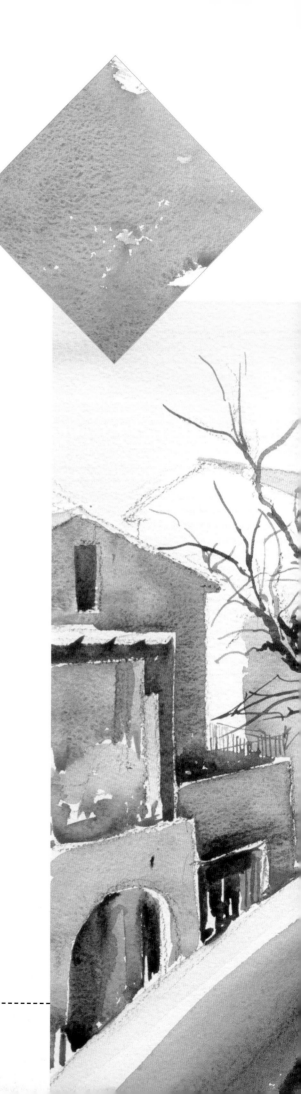

4

4. Over this painted and completely dry area, the tree branches are easily added with a dark color and without charging the brush with too much paint. It is like calligraphy work, a linear ornament that extends across the color surfaces of the landscape. Observe the attention given to the spherical volume of the baluster, which reinforces the overall illusion of space.

THE ARTIST COMMENTS

The light-filled scene has been successfully created thanks to the great contrasts of light and dark (warm lights and cool darks). These contrasts energize the color, especially if we take into consideration the fact that the opposing colors are complementary (the violets complement the orange yellows) (A). In addition to these vigorous contrasts there are also light and gray nuances on the trees (B) and contrasts between complementary colors, even when diluted, on the façades (C).

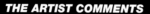

B

C

Portrait
in a Drawing Style

the superiority of color over drawing has been a widespread
sentiment since the Impressionists introduced their colorful
working style. However, it is not something that the artist
must be compelled to follow. The work shown here used
drawing as the guiding force of the work. This portrait, done
from a live model by David Sanmiguel, was developed with
line drawing (a drawing done with a brush and paint); color
played a discrete, although decisive, role in the final stages.

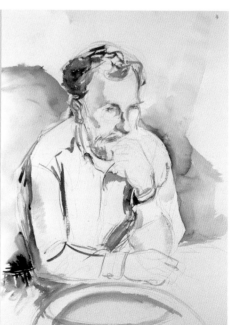

1. There is no doubt that creating a subject entirely in
pencil requires practice and mastery, in other words, it
requires experience. But it is also true that if we work with
very diluted paint, which is later covered, we can make
many corrections as we go. The drawing establishes the
guidelines for the entire watercolor and the colors follow it
from the beginning with a very small spectrum: Payne's
gray, burnt sienna, and ultramarine blue.

1

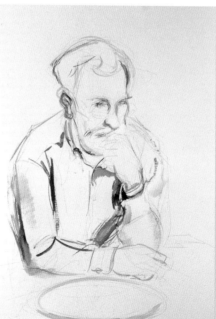

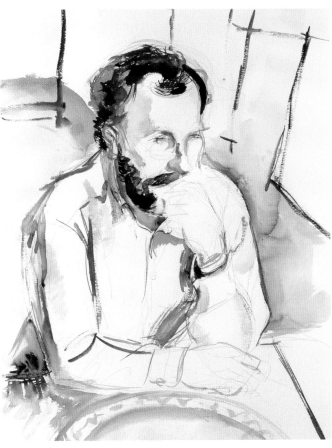

2

Defining the drawing with lines of different colors creates very spontaneous features, such as these hands in which the natural color gives way to a graphic style.

2. Even though the head is the most detailed part of the work, there are large areas of color that define the background and the darkest areas of the figure. Also, the brushstrokes that define the platter help establish the foreground and create a feeling of depth.

3

3. The head, as the focal point of the portrait, is in front of the other areas of the watercolor. The hair is worked with very saturated Payne's gray, mixed in some areas with burnt sienna. The brushstroke is very important and has to suggest the curls and the waviness of the hair and the beard. The features, on the other hand, are not defined completely, but are left in a semi-sketchy form and are finished at the end of the process.

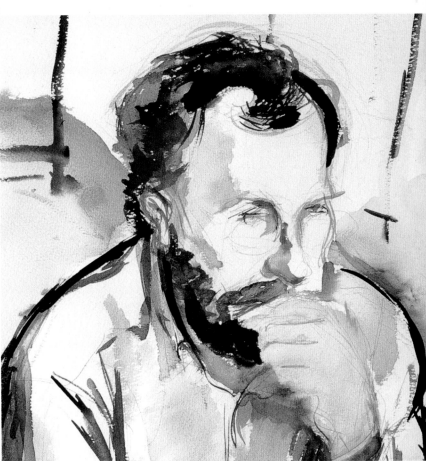

4

4. A more advanced stage of the portrait where the main concern is to give shape to the body of the figure by using areas of different values of Payne's gray. These colors are applied with a wide flat brush that glides with great ease. The result is a fresh and suggestive composition of tones that allow the white of the paper to breathe.

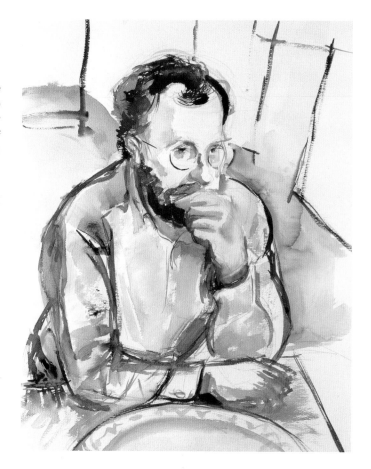

THE ARTIST COMMENTS

The background has been almost exclusively painted with Payne's gray, which, thanks to its wide tonal range, makes it possible to create many varied cool effects (A). The treatment of the figure has been, from the beginning, basically dependent on the drawing; even in the last phase of the work, lines are used to complete important details, like the hands (B). The eyes and the nose have been represented very carefully, emphasizing the delicate glass frames, but not too much: just a few touches are enough to establish the gaze of the model (C).

A

B

C

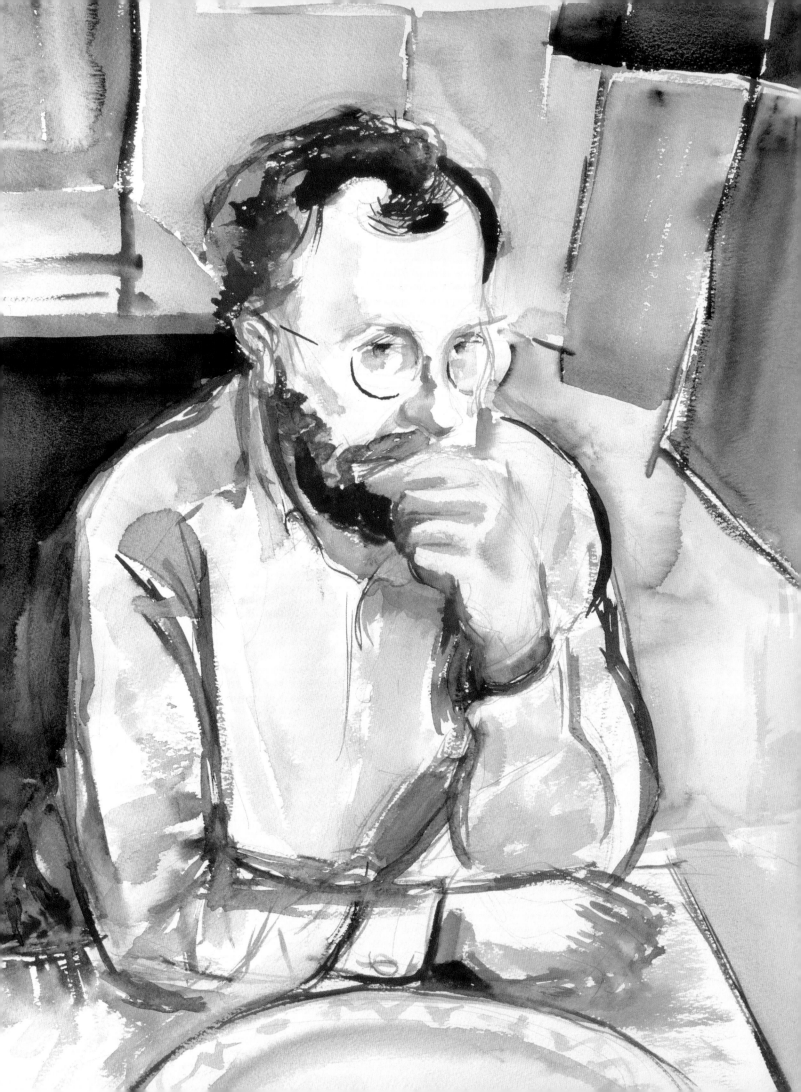

Portrait of a Child

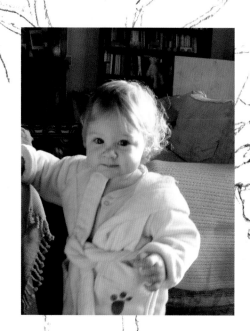

Children's portraits are not easy for several reasons. First, because it is almost impossible to make a young child pose for us. The artist is forced to work from photographs, with the subsequent problems (artificial lighting, very flat forms, and so on). On the other hand, children's features are delicate and it is easy to fall into exaggeration and caricature. These problems, and also the rewards of working with this subject matter, are demonstrated here by the hand of Mercedes Gaspar.

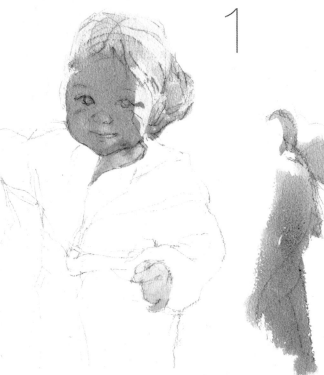

1

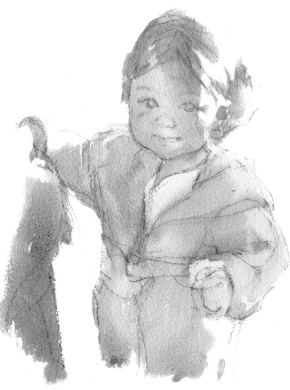

1. Pencil drawing is an important part of this exercise. No matter how simple the preparation, the resemblance must be present from the beginning. The background is left undefined and the figure's features and relevant anatomical elements are the only aspects that are drawn. The first applications of color are made with burnt sienna and ultramarine blue, with the artist striving for warm tonalities and leaving several areas of the hair (the light reflections on the blond hair) unpainted.

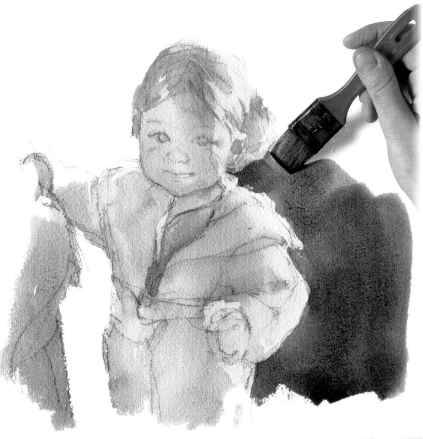

The drawing for this work is done with a watercolor charcoal pencil. Interestingly enough, the black pencil line has a violet tendency when it is wetted with the brush. This is the reason for the mauves and purple nuances that are clearly visible in different parts of the work, especially during the first stages of the painting.

2

3

2. The figure is painted with a light gray wash that gives the body volume. This volume is emphasized by the strong contrast against the warm, dark background. The artist uses a flat brush to paint this color and reserves the rest of the body, in other words, she avoids painting inside the line with this new color that is so dark.

3. As with the previous step, it is now a matter of working the outline of the figure. It is a good idea not to touch up too much, to simply leave the features sketchy so as to not charge the expression. The illustration shows the simple approach for the chair's fringe: all done through reserves of the background color.

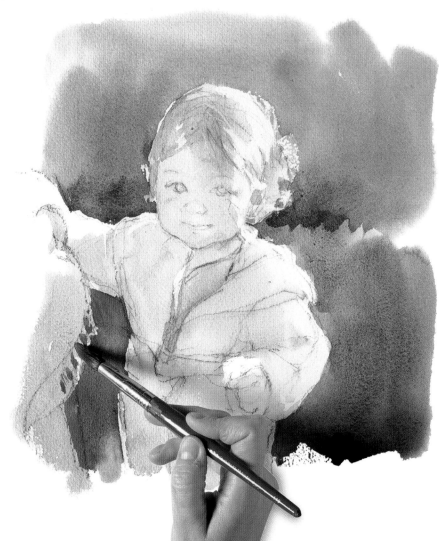

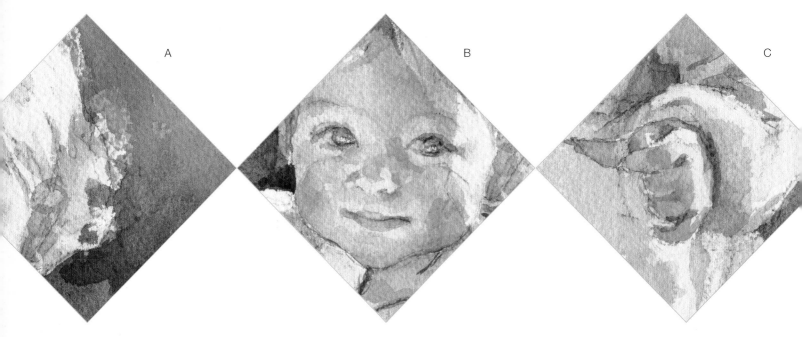

A B C

4. The background is finished: it is purposely left sketchy to prevent it from competing with the child's face. It is time to finish the portrait by touching up the facial features, incorporating shadows, and modeling the entire face delicately. The colors used are the same ones used for the background, but are much more diluted in water.

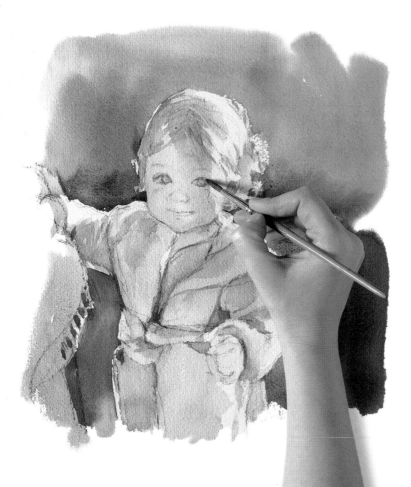

THE ARTIST COMMENTS

As with every portrait, the most interesting aspects of the finished work are centered on the figure's head. The white reserves have made it possible to faithfully represent the blond curls (A). The facial features are perfectly clear yet without too much contrast, as is appropriate for such a young child (B). In accordance with the rest of the body, the hand was painted in a very simple and creative way, shading only the fingers and leaving the rest almost unpainted (C).

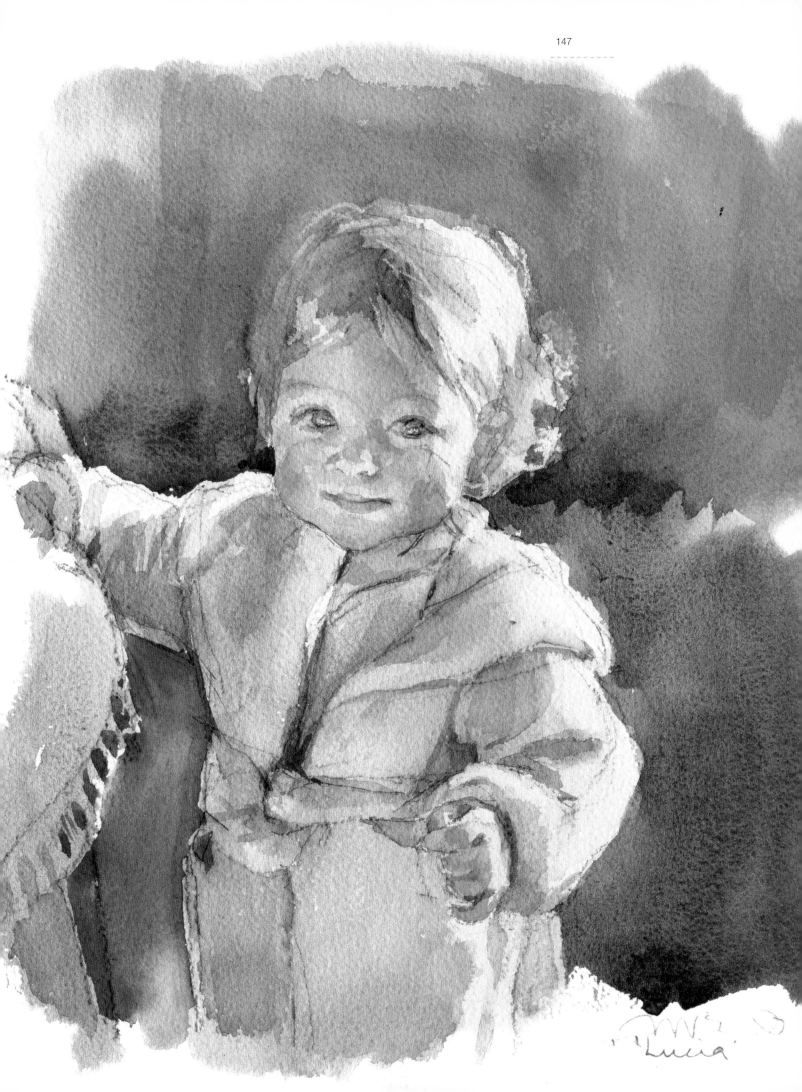

Lucia

A Large Bouquet
of Lilies

flowers represented in this spectacular fashion are one of the most attractive subjects that one can imagine. These beautiful white lilies, highlighted by the late morning light that comes in through the window, are an explosion of color despite the fact that they are all white. The infinite nuances created by the semitransparency of the petals and the shadows projected by the leaves are more than enough to provide an exuberant sense of color. This watercolor was created by Óscar Sanchís.

1. The subject is first drawn with lines, using a pencil that is not too soft. The drawn lines are not shaded or reinforced. It does not matter if the movement does not mimic the model exactly, since there will be an opportunity to touch up the forms during the process; what is important is for the forms to create a well-proportioned composition. The first flowers are dampened before painting and then diluted paint is applied, violet (for the whites) and sienna (for the stems and the shadows).

1

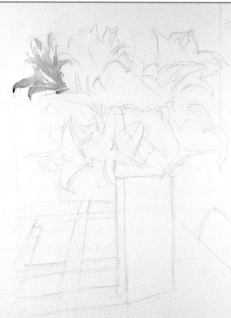
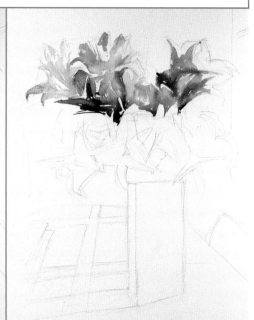

The brushstrokes are applied neatly over the areas left white, making sure the paint stays inside the lines. These dark brushstrokes stand out in the foreground, in contrast with the airy tones of the petals.

2

2. The darkest areas are painted with a mixture of green, ochre, and violet. The mixture should not be completely homogenous and each color should be distinctly visible (to a certain degree) within the brushstroke to give the subject depth and pictorial interest. The work progresses methodically, from top to bottom, with the artist adjusting each flower's position based on the quick preliminary drawing.

3

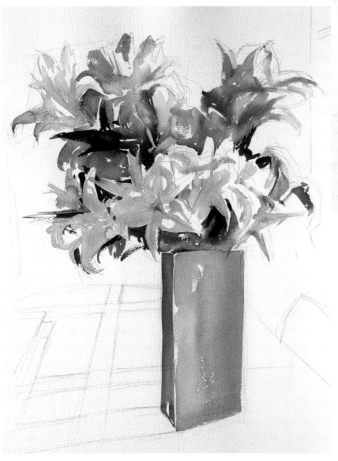

3. Watercolors are not the most suitable medium for composing a painting with blocks of solid colors; their nature makes them much better for creating the mood through brushstrokes and transparent applications, combining very diluted colors and strokes of nearly dry color. Therefore, the vase has been created not with a single layer of uniform color but with an application where the marks of the brush can be seen. The charm and expressivity of this work is based on the contrasting brushwork. Here, the combination of lines and colors is as important as the color harmony itself.

4. The artist works slowly and carefully, waiting for the base colors to dry before applying more defined brushstrokes. The effect of the petals is based on the contrast between defined and undefined elements. As for the background, it should be sketchy without details; in fact, the latter should be avoided so as not to take away from the flowers.

4

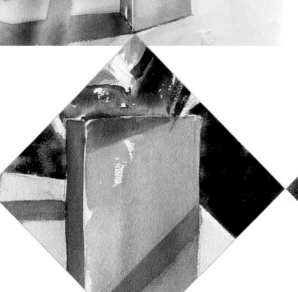

A

B

C

The tones of the flowers are delicate, but their color contrasts vividly against the diluted undefined dark background. The color's luminosity is created by applying delicate colors diluted in large amounts of water. The complexity of the forms and colors in the central area of the watercolor is achieved by paying great attention to the definition of each color and alternating transparent and saturated tones (A). The vase is a very delicate surface that is resolved with a single brushstroke (B). The uppermost flowers stand out as reserves against the very dark background, which strengthens their luminosity (C).

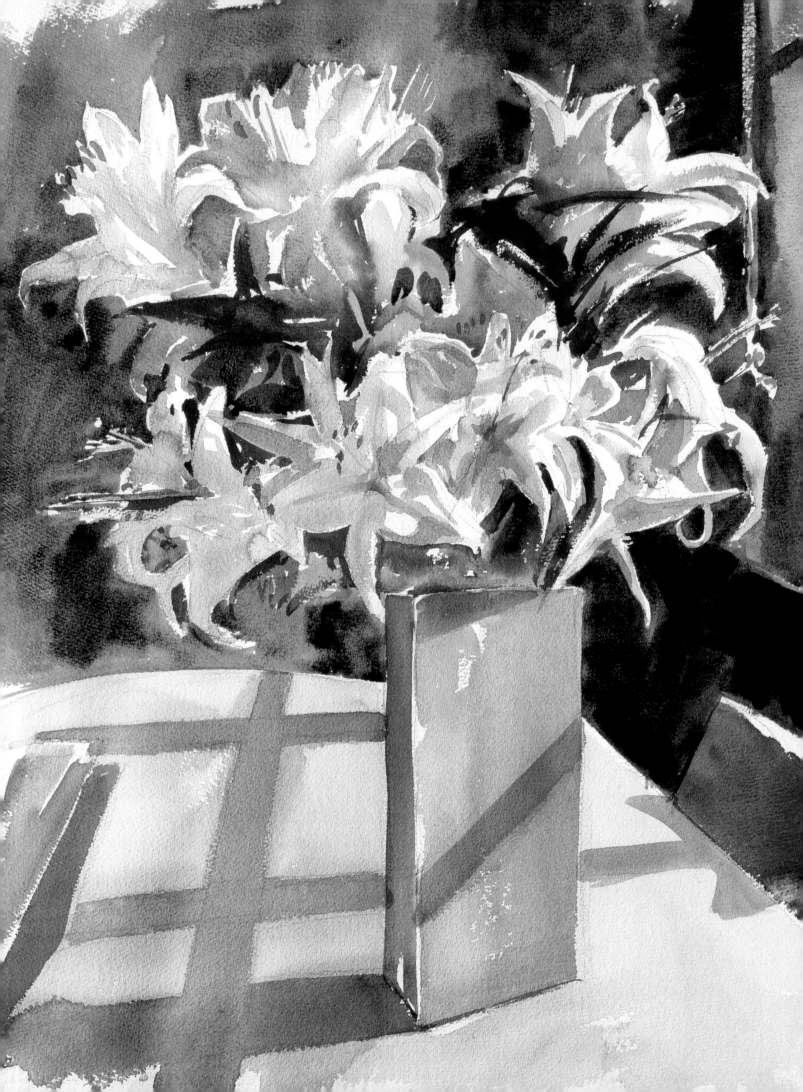

Still Life
with Food

1

this is a subject that occurs almost spontaneously: a table set for cocktails, with crystal glasses, objects of very different forms and materials, food, and especially, a luminous and varied combination of lights and shadows created by the bright morning sun. It is a contemporary still life with great visual interest that challenges the watercolorist, even the most expert, with every possible scenario. Shown here is only part of the process (by Óscar Sanchís), where only the most significant groups of objects from the scene are addressed.

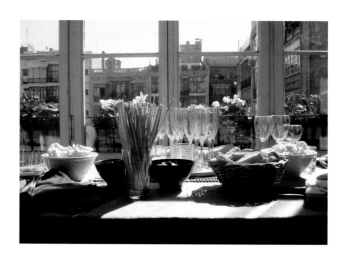

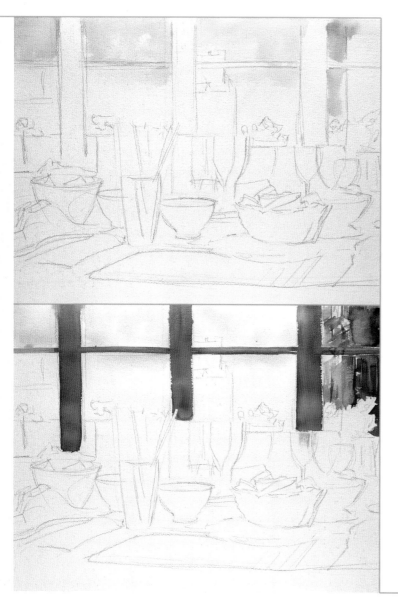

1. The drawing is slow and time-consuming. It is very important to block in each element (and there are many) in its appropriate place in such a way that it does not appear hidden and so it can easily be recognizable. The drawing is strictly linear and addresses only the outlines. Next, the sky is colored with a very light wash and the window frames painted to provide a sound structural base to a subject that is quite challenging.

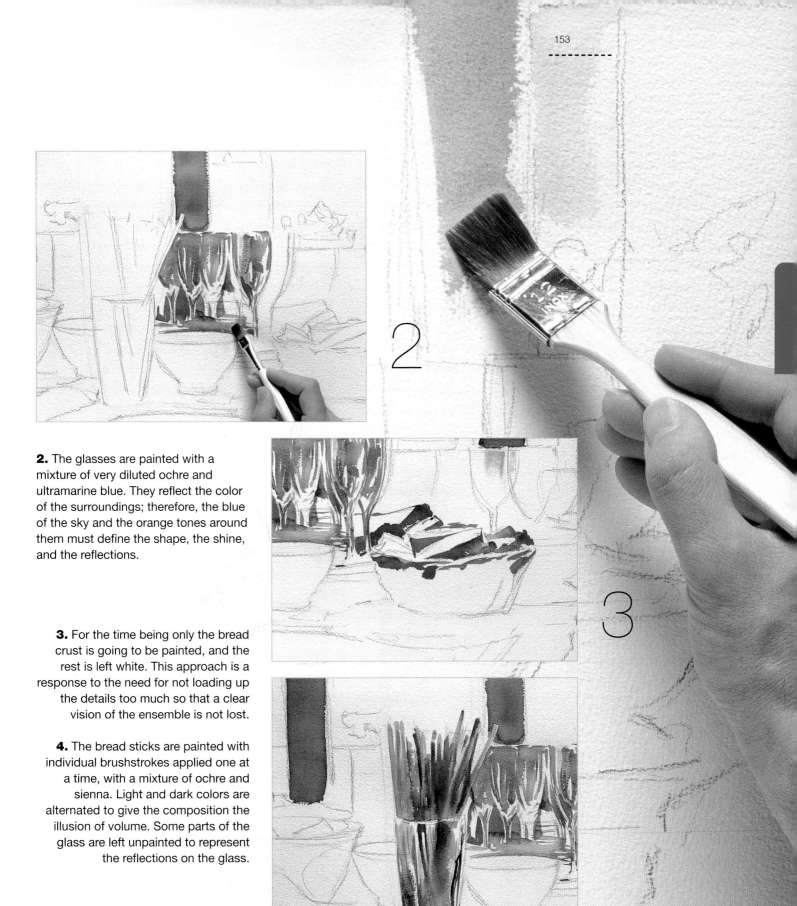

2. The glasses are painted with a mixture of very diluted ochre and ultramarine blue. They reflect the color of the surroundings; therefore, the blue of the sky and the orange tones around them must define the shape, the shine, and the reflections.

3. For the time being only the bread crust is going to be painted, and the rest is left white. This approach is a response to the need for not loading up the details too much so that a clear vision of the ensemble is not lost.

4. The bread sticks are painted with individual brushstrokes applied one at a time, with a mixture of ochre and sienna. Light and dark colors are alternated to give the composition the illusion of volume. Some parts of the glass are left unpainted to represent the reflections on the glass.

5

5. The artist continues to work around the midsection of the composition, paying no attention to elements other than those seen there. This way, the work grows from inside out, always maintaining balance and harmony. Little by little new elements are added without making any attempt, for the time being, to apply any strokes to unify the composition.

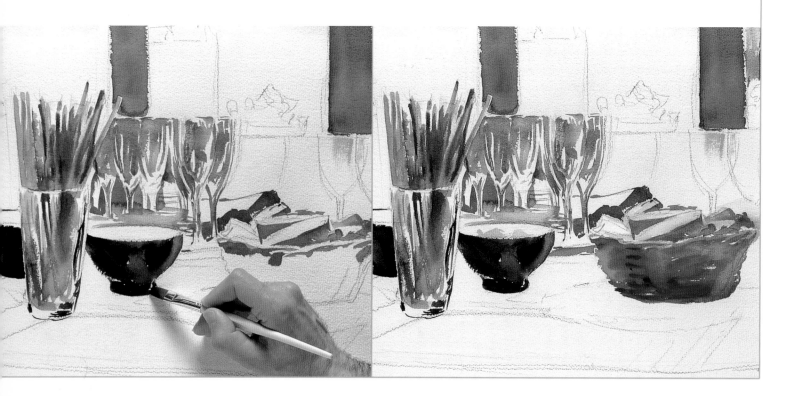

6

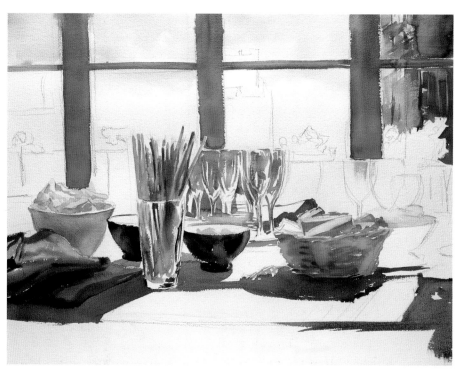

6. When all the elements in the center of the composition have been addressed, we begin to tie together the group with lights and shadows. These more or less uniform colors visually connect and relate the objects to each other, enhancing their placement in the space.

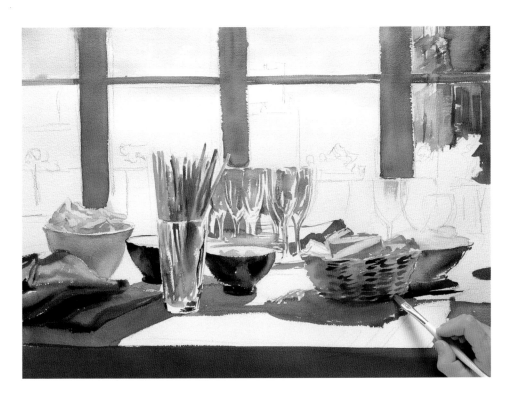

Controlling the water has been very important in the meticulous approach to each piece of the still life. Sometimes the corner of a piece of blotter paper has been used to absorb the excess water that threatened to run across the paper.

7. Only after the shadows on the tabletop have been painted can the objects be touched up and completely finished, because it is at this stage that the artist has all the references to shape and color on the paper.

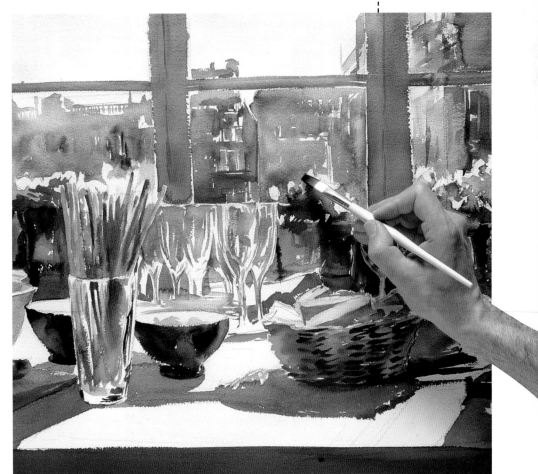

8. The flowerpots and the background of the composition, with its concentration of buildings and architectural details, are the last to be resolved. It is very important to leave these areas partially finished, or at least not to carry them to the same level of completion as the main objects of the still life, otherwise confusion would reign in this naturally complex work.

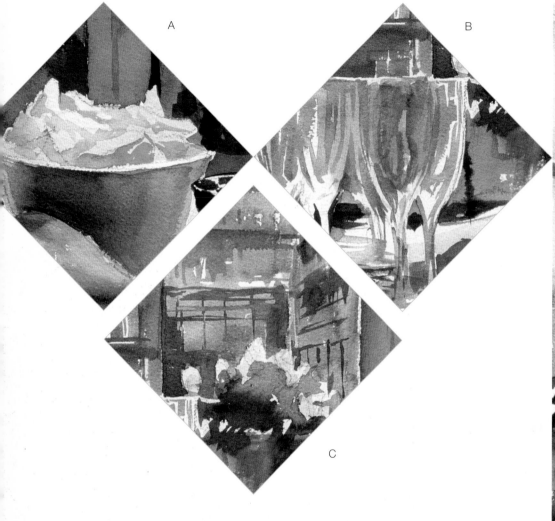

A

B

C

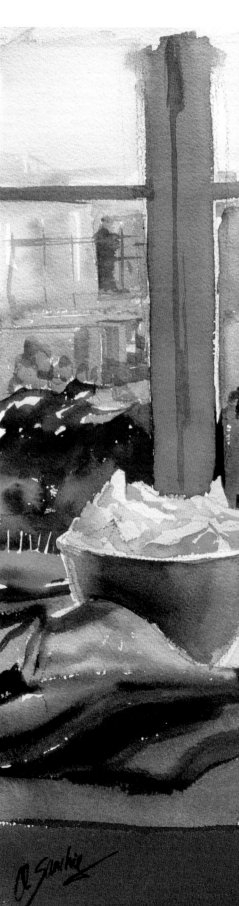

THE ARTIST COMMENTS

Painting this watercolor has taken several hours. The result is spectacular: the great number of details and intricacies neither distract from nor minimize the scene; on the contrary, it is a work of great visual quality. As for the technical quality, the mastery with which each element has been addressed is evident. The French fries indeed look real with their very delicate yellow tones (A). The glassware is extraordinarily transparent (B), and the secondary areas, still quite sketchy, evoke the architectural features perfectly (C).

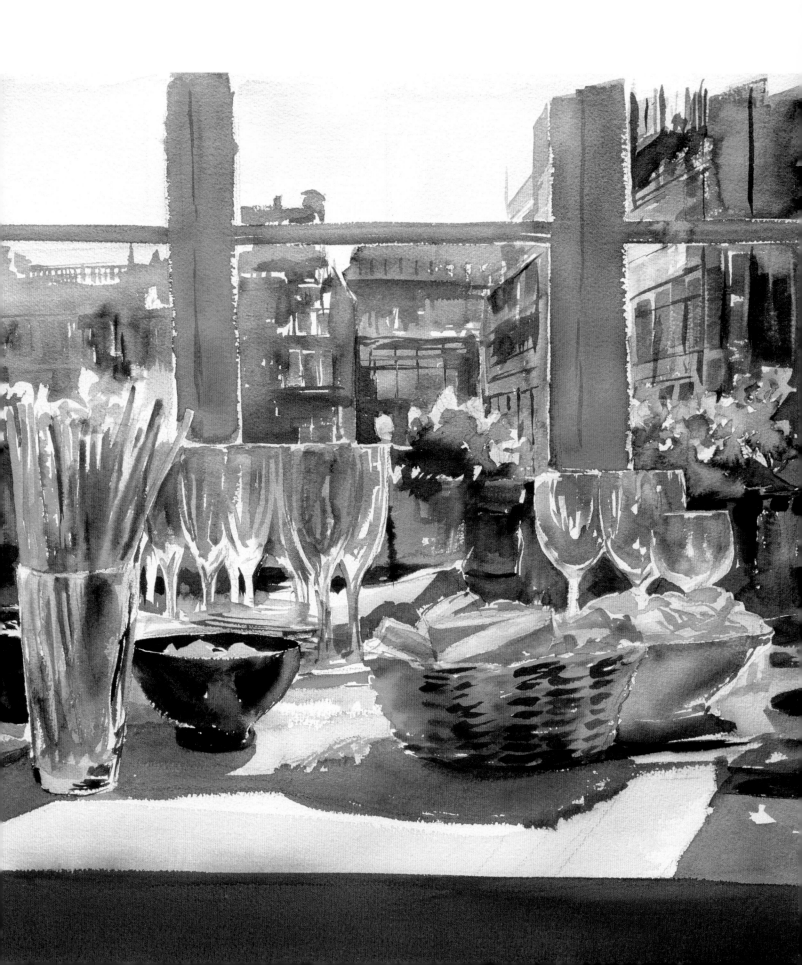